A Handbook of
Biological
Illustration

A Handbook of Biological Illustration

By

FRANCES W. ZWEIFEL

PHOENIX BOOKS

THE UNIVERSITY OF CHICAGO PRESS

CHICAGO & LONDON

PHOENIX SCIENCE SERIES

THE UNIVERSITY OF CHICAGO PRESS, CHICAGO & LONDON
The University of Toronto Press, Toronto 5, Canada

© 1961 by The University of Chicago. Published 1961
Third Impression 1965. Printed in the United States
of America

INTRODUCTION

Purpose and Scope of Work

This book is intended primarily for the guidance of the student or professional biologist who is unfamiliar with materials and techniques of illustrating and who may find it necessary to prepare his own illustrations for classroom assignments or scientific publications. An artist unaccustomed to working with biological materials may well be adept at illustrating techniques but may be confronted by problems peculiar to biological illustrating. This person, too, may find useful suggestions within.

Black-and-white drawing.—The principal emphasis of this book is on black-and-white drawing, for this is the most commonly used form of biological illustration. It is hoped that, by following the suggestions in this work, the biological illustrator will be able to proceed from the preliminary sketch to the mounting and shipping of the finished illustration with a minimum of difficulty. To this end, time- and labor-saving materials and techniques and small but helpful details have been stressed. The production of clear and attractive charts, graphs, and maps, so important in scientific papers, has received coverage, along with the more familiar drawing of real objects.

Color illustration.—The subject of illustrating in color receives less complete attention. Competence in the use of color as an artistic medium is achieved only with much practice and study, whereas the production of adequate (if not truly artistic) black-and-white illustrative material is within the reach

of many if not most persons. Moreover, while there is scarcely a scientific journal that will not reproduce black-and-white figures, the cost of reproducing color is so high that only the true professional can aspire to see his work published, and then rarely in scientific journals.

Photography.—The methods and techniques of photography are not within the scope of this handbook. However, the use of photographs as an aid to drawing, retouching photographs, and cropping and mounting photographic prints are discussed.

Photography, drawing, and painting supplement one another as media for biological illustrating. Each method has its own advantages and disadvantages. In a photograph the desired focus and lighting may be difficult to achieve, and the photograph may thus impart a false impression. Structures lacking sufficient contrast may be difficult or impossible to show by a photograph but yield to the eye and pen of the artist. A drawing may in this manner direct emphasis and avoid confusion. Because of parallax, two different photographic views of the same structure may give different measurements; such inaccuracy can be detected and compensated for in drawing.

Copying and Copyrights

Copying.—The practice of copying another's artwork for publication is inartistic as well as unethical. There are several reasons why this is so. Through copying, previous errors may be perpetuated or exaggerated, or new errors may be introduced; the original artist was conveying his own impression of the original model, which may be quite different from the impression the copyist may have wished to convey had he seen the same model; and copy of any rendering usually lacks liveliness of line, feeling of originality, and the artistry of the

original artwork, as one can prove by attempting to copy his own drawings.

Copyright.—If one must copy from another's illustration (if, for example, no model from which to work is available), he must take care to give credit to the original artist and to mention the source of the original illustration. If an illustration previously published and copyrighted is to be used in a publication, the author must be certain to obtain written permission from the copyright owner to use the illustration, as well as publishing a credit line.

Acknowledgments

An early draft of this handbook was submitted as a thesis to the Art Department of the University of Arizona, and I wish to thank all those who helped and encouraged me then. Chief among these are Dr. Robert M. Quinn, Dr. William H. Brown, Dr. Charles H. Lowe, Jr., and Mr. Donald B. Sayner.

Most sincere appreciation is expressed to those many persons who have patiently contributed so much help and constructive criticism, especially my former colleagues at the American Museum of Natural History, and chiefly to my husband for his endless editorial tasks.

Thanks are also due several firms for permission to illustrate or mention their products and for some of the illustrations used in the text: The Craftint Manufacturing Company; Keuffel and Esser Company; Arthur Brown and Brother, Inc.; Para-Tone, Inc.; and Charles J. Ross Company.

CONTENTS

LIST OF ILLUSTRATIONS xiii

1 PRINTING PROCESSES 1

Reproduction in Small Quantities 1

Reproduction in Large Quantities 4

Color Reproduction 12

Selected References 13

2 SIZE AND REDUCTION OF ILLUSTRATIONS FOR PUBLICATION 14

Advisability of Reduction 14

Planning the Copy Size 14

Selected References 19

3 MATERIALS 20

Rough Drafts and Pencil Drawings 20

Ink Renderings 20

Scratchboard Drawings 21

Dry-Brush Renderings 21

Charcoal Renderings 21

Black-and-White, Using Special Grounds 21

Wash Drawings 22

Watercolor Paintings 22

Gouache Paintings 22

Casein or Oil Paintings 22

Maps and Graphs 23

Lettering 23

Retouching and Drawing over Photographs 23

Mounting Illustrations 24

Miscellaneous Materials and Equipment 24

Selected References 24

4 *DRAWING* 25

Introductory Remarks 25

Measuring the Subject, Using Common and Special
 Drawing Aids 29

Drawing Live Animals 43

Black-and-White Line-Cut Illustrations 45

Toned Illustrations 62

Methods of Correcting Mistakes 68

Selected References 69

5 *PREPARATION OF GRAPHS AND MAPS* 71

Materials and Special Techniques 71

Graphs 85

Maps 94

Selected References 103

6 *LETTERING* 104

Introductory Remarks 104

Freehand Lettering 106

Mechanical Lettering Systems 108

Selected References 115

7 *ILLUSTRATIONS FROM PHOTOGRAPHS 116*

Retouching Photographs *116*

Lettering on Photographs *123*

Drawings from Photographs *123*

Selected References *124*

8 *MOUNTING AND HANDLING ILLUSTRATIONS 125*

Mounting Illustrations *125*

Protecting Illustrations *127*

Identifying Illustrations *128*

Mailing Illustrations *128*

INDEX 129

LIST OF ILLUSTRATIONS

1. Zinc Cut 7

2. Copper Cut 8

3. Halftone in Two Different Screens 9

4. Enlargement of a Small Section of Figure 3, Showing Magnified View of Halftone Screen; Part of Figure 3 Printed To Show Moire Effect 10

5. Illustration with Reduction Directions Indicated in Margin 15

6. Method of Planning Copy Size and Reduction Size 17

7. Method of Obtaining Aerial Perspective in a Line Drawing; Use of Arrows and Labels within a Drawing 28

8. Enlarging Measurements Taken with Simple Dividers 30

9. Proportional Dividers 31

10. Blocking-in a Drawing; Fur Technique 33

11. Measuring a Three-dimensional Object in One Plane 34

12. Diagram of the Parallax Problem 35

13. Drawing, or Changing the Size of a Drawing, by Using Co-ordinate Squares 36

14. Principle of the Camera Lucida 37

15. Pantograph 38

16. Baloptican Projector 41

17. Microprojector 42

18. Correct Position of Hand Holding Drawing Pen 46

19. Subject Drawn with and without Outlines 48

20. Method of Continuing a Broken Inked Line 48

21. Joining Inked Lines 49

22. Hatching and Crosshatching 52

23. Coquille Board *54*

24. Ross Stipple Board *54*

25. Dry-Brush Technique *56*

26. Steps in Making a Scratchboard Drawing *58–60*

27. Rolled-Paper Smudger *63*

28. Flat and Round Brushes *64*

29. Railroad Pen *73*

30. Ruling Pen *74*

31. Leroy Socket-holder and Socket in Penholder *74*

32. French Curves *75*

33. Flexible Curved Rule *75*

34. Drawing Parallel Lines by Using a Compass *77*

35. Drawing Parallel Lines by Using a T-Square and Diagonal Line *77*

36. Drawing Parallel Lines by Using Two Diagonal Lines *78*

37. Drop-Compass *79*

38. Rule Raised from Surface of Paper *80*

39. Craftint Shading Patterns *81*

40. Zip-a-Tone Patterns *82, 83*

41. Scatter Diagram *86*

42. Polar Scatter Diagram *87*

43. Frequency Polygon; Raw Data *88*

44. Frequency Polygon; Grouped Data *89*

45. Combination of Line and Scatter Diagrams *90*

46. Histogram *91*

47. Bar Diagram with Modified Dice Squares *92*

48. Bar Diagram with Shading Patterns *93*

49. Sector Diagram *93*

50. Three-dimensional Diagram *95*

51. Map with Shading Films *96*

52. Common Errors in Mapping *98*

53. Bar Diagram Combined with a Map *102*

54. Freehand Lettering *107*

55. Leroy Lettering Set *109*

56. Preparation of a Base Rule for Use with a Scriber Lettering System *111*

57. Hand and Scriber, Leroy System *113*

58. Scriber Lettering, Original Size and Reduced *114*

59. Silhouetting a Photograph *117*

60. Original Version of a Photograph *118*

61. Retouched Version of a Photograph *119*

62. Drawing from a Bleached Photograph *120*

1 PRINTING PROCESSES

An understanding of the printing process which the originals will undergo is essential to the artist. Not every illustration can be reproduced by any printing process, and some processes are suited to a particular drawing technique. If the process to be used is known beforehand, the artist will be able to employ the technique which is best reproduced by this printing process. If cost of publication is important, it will be well to plan an illustration which may be reproduced by an inexpensive method. It is an advantage also to know what kind of paper will be used for the reproduction, as the kind of surface will determine, to some extent, the detail that will be reproduced and may thus influence the time and care devoted to preparing the illustration.

Reproduction in Small Quantities

There are several means of reproducing illustrations in small quantities, such as are needed for thesis illustrations or for distribution in a classroom.

Stencil copying.—A familiar name in this process is "mimeograph." To copy a printed or drawn work, a stencil is "cut" on special wax-coated paper. Printed stencils are made on a typewriter adjusted so that the ribbon does not come between the type and the stencil. Solid, broken, or dotted lines may be drawn with special tools. An illustration may be shaded by stippling, by hatching, or by using special pattern screens which are pressed into the stencil, leaving a pattern of dots or lines. The typing and other marks are breaks in the wax coat-

ing of the stencil. Ink is applied to the stencil and penetrates the exposed paper but not the areas still waxed. By means of a revolving drum, the stencil is brought in contact with the paper to be printed. As many as several hundred copies can be made before the stencil becomes too worn. Ink is available in several colors.

Hectographing.—The hectograph consists of special ink in a gelatin plate. A "master" is made with any color hectograph ink; this is applied to a plate of special gelatin material and allowed to "set" for a short time. When the master sheet is removed, the gelatin plate has absorbed the ink and will transfer it to other paper placed on it. One treatment of the hectograph plate will print fewer copies than a mimeograph stencil.

Blueprint.—The illustration to be blueprinted must be done on good-quality tracing paper. The blueprinting process depends on the passage of light through the transparency, any opaque marks being printed. Corrections on a blueprint, therefore, must be erased from or cut out of the tracing paper. Blueprinted illustrations are not enlarged or reduced from the original size and are printed on special blueprint paper coated with a blue or black emulsion. (Blue coating generally makes a better print than black coating.) Blueprinting is a dye-stain process and consequently is not permanent. Brown printing is more durable than blueprinting and slightly more expensive.

Ozalid is similar to blueprint but is a dry process and more lasting than blueprinting.

Because of its impermanence, the blueprinting process is sometimes not acceptable for theses. The student should check with his thesis committee.

Photostating.—Any illustration which is definitely black and white without intermediate grays can be photostated. This includes maps, graphs, tables, pen-and-ink drawings, and half-

tone proofs which already have been printed. Since the photostat machine will not reproduce a gray line or area, anything to appear in the print must be blackened before photostating. The photostat machine reproduces photographically, making a paper negative from the original illustration. This negative is "right-reading," not reversed, as is a transparent-film negative, as the usual reversal caused by the camera lens is counteracted by a prism in position before the lens. A standard photostat machine will enlarge an illustration up to twice its original dimensions (four times the original area) or reduce it to one-half its original dimensions (one-fourth the original area) and will reproduce any size between these limits. For ease and generally best results, an illustration to be photostated should be prepared one and one-half times the desired final size, as the one-third reduction will clear and reduce imperfections without losing detail.

Illustrations to be photostated should be done on good-quality, pure-white Bristol board, illustration board, scratch-board, or plate-finish drawing paper. By "pure white" is meant photographically white, which includes light blue but not cream white. The drawing should be clean and open, with purposeful lines and stipple, not sketchy and weak. Very fine lines are likely to break or close up when photostated. The final positive print is made by photostating the paper negative. As some slight reflection of light from the surface of the negative into the camera is unavoidable, the positive will be somewhat blurred. The artist must take this into account and should space his lines and stipple dots wider than he may actually want them.

Errors and parts to be omitted from photostated illustrations are painted black on the paper negative. Corrections may be indicated on the original, therefore, and are painted out of the negative.

Photographic printing.—If a wash drawing or a photograph

is to be reproduced in a small quantity, it can be photo-graphed and a contact print or enlargement made from the film negative. This is done on special photographic paper that is suitable for a thesis page. Shadow lines from pasted titles will appear in the print as faint, gray lines unless opaqued on the negative. All smudges and unwanted pencil lines must be removed from the original before photographing. Illustrations to be printed in this way can be reduced as well as en-larged.

Reproduction in Large Quantities

Illustrations to be produced in large quantities, such as those in scientific journals or books, are printed from plates. There are three classifications of printing plates: relief, intagl-io, and planographic.

In a relief plate the printing surface is in relief, or raised from the rest of the plate. Photoengravings are made from relief plates. The printing surface is sunken below the surface of an intaglio plate. Gravure, which is now rarely seen, is an intaglio printing process. In a planographic plate the printing surface is on the surface of the plate, and printing depends on the ink-repelling action of water to oil. Offset printing and lithography are planographic processes.

Collotype, or photogelatin plates, resemble both plano-graphic and intaglio processes because the printing surface, though differentially receptive to water and ink, is also de-pressed in the ink-holding surface and raised in the ink-rejecting areas.

Photoengravings.—There are two major classes of photoen-gravings: line reproductions and halftone reproductions. Both are printed by relief plates.

A *line cut* is used to reproduce an original picture in which the outline and tone are represented by lines, dots, and defi-nite solid areas. A line cut cannot reproduce a continuous-

tone effect. It will reproduce only black and white, not gray. Any line or dot that is meant to appear in the reproduction must be drawn solidly black in the original.

Line cuts are made from zinc, copper, magnesium, and, sometimes, aluminum. Copper will take finer detail than will zinc and is stronger, but it costs approximately twice as much as zinc and so is less frequently used.

The original illustration is photographed, making a negative the desired size of the reproduction. This negative is printed on a polished sheet of metal which has been coated with a photographic emulsion. The metal is treated with acid that will eat away the background, leaving the image standing in relief. The metal plate is nailed to a piece of wood which is type-high, that is, the printing surface of the plate stands as high as type. The plate and type thus may be printed together on a page.

Illustrations that will be reproduced satisfactorily as line cuts may be pen drawings in black ink on any good, white drawing paper; brush and dry-brush drawings; black crayon and charcoal drawings that show no actual gray; scratchboard, Coquille board, and Ross stipple-board drawings; and illustrations employing special materials, such as Craftint shading patterns, Bourges shading sheets, and Zip-a-Tone. These last special materials are discussed in chapters 5 and 6.

Figure 1 is a zinc cut reduced one-fourth from the original size (one-fourth off); Figure 2 is a copper cut reduced in the same proportion.

The *halftone* process is used to reproduce an original in which the subject is depicted in a continuous-tone manner. Photographs and some wash drawings and pencil drawings can be reproduced by halftone.

The halftone plate is a relief plate and, like a line cut, prints only black and white. A halftone print examined through a magnifying glass is seen to be composed of indi-

vidual black dots of varying sizes. The effect of the halftone plate thus depends on an optical illusion, in which these tiny dots seem to blend into different shades of gray (see Fig. 3).

In the preparation of a halftone plate the breaking-up of continuous tone into individual dots is accomplished by means of a screen inserted into the camera between the lens and the sensitized photographic plate. This halftone screen consists of two sheets of glass, each etched with equally spaced opaque, black lines. These sheets are placed so that the lines are at right angles, forming a network or grid (see Fig. 4).

The halftone plate is produced in the same manner as the line plate. The screen filters the light entering the camera so that the image is broken up into dots on the negative. This is printed on copper which is then treated with acid. The completed halftone plate is a series of dots standing in relief. It is mounted type-high, as is a line cut.

Screens are ruled with 65 to 150 or more lines to the inch. Very fine halftones use 150–75-line screens. The finest halftone reproduction requires not only a fine screen but also high-quality paper, increasing the cost of reproduction.

Because the screen covers the whole negative, no absolute white is reproduced by a halftone plate. If pure white is required, the white areas must be tooled out of the plate by the engraver, which adds to the expense of the printing. Gradation which is barely discernible in the original cannot be expected to reproduce in the halftone, since dot formations tend to weaken delicate work. Fine lines will appear as dotted lines and may be weakened or lost in the halftone reproduction.

Some editors require that a photograph to be reproduced as a halftone be submitted as a glossy print, but others prefer the original negative. An attempt to make a halftone reproduction from a previously published halftone illustration is usually most unsuccessful, owing to the resulting moire effect. The cause of the moire effect is the conflict between the line

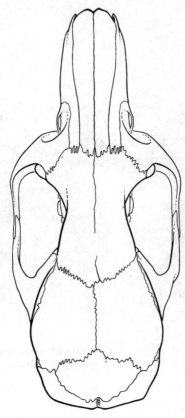

Fig. 1.—Example of a zinc cut. Dorsal view of the skull of a giant rat, *Xenuromys barbatus*. Reduced one-fourth from the original scratchboard drawing.

8

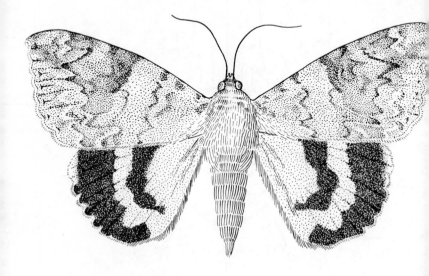

Fig. 2.—Example of a copper cut. Dorsal view of an underwing moth, genus *Catocala*. Reduced one-fourth from original pen drawing.

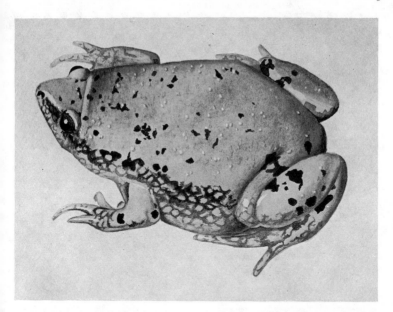

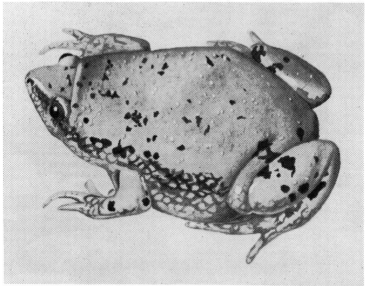

Fig. 3.—Example of a halftone illustration, showing the effect of two different screens, 75 and 150 lines per inch. Reduced one-half from original wash rendering of a narrow-mouthed frog, *Microhyla mazatlanensis.*

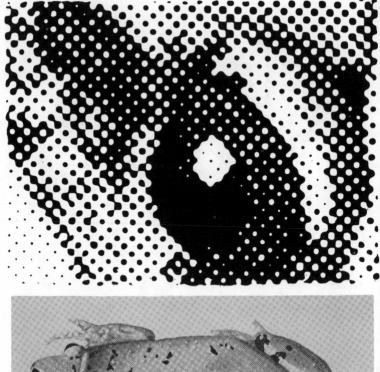

Fig. 4.—*A*, Enlargement of a small section of Figure 3, showing a magnified view of a halftone screen. *B*, Figure 3 printed to show moiré effect achieved when a halftone illustration is made from a halftone copy.

or dot formation of the proof and the ruling of the second halftone screen. The effect may range from a "watered-silk" look to an unpleasant checkered appearance (see Fig. 4). There are several ways to minimize or eliminate moire, but the best rule is not to submit a halftone to be reproduced by halftone.

Although wash and pencil drawings may be reproduced in halftone, they are best done by offset or collotype printing.

Offset.—Offset is a planographic process, sometimes called "photo-offset" or "offset lithography." In true lithography the subject is drawn on a slab of limestone (or a sheet of zinc) with grease or a grease crayon. The slab is dampened and then inked with a greasy ink. Paper is pressed on the surface and picks up the ink. If zinc is used, the plate may be rolled on a cylinder.

In offset lithography the zinc or aluminum plate is fastened to one of three cylinders of the offset press. The image is printed on a second, hard rubber-covered cylinder and in the course of printing is transferred from this to the paper which runs over the third cylinder. Because rubber instead of hard metal is pressed against the paper in the offset process, a thinner film of ink may be used, resulting in much finer reproduction. Both line work and halftone work are reproduced by offset, with screens as fine as 300 lines per inch capable of giving sharp, clear prints. Finer lines and stipple can be reproduced by offset than is possible by photoengraving. Wash and pencil drawings and photographs can reproduce better by offset. In page size or smaller illustrations, the cost of offset is usually greater than that of photoengraving. Large fold-out illustrations that sometimes appear in scientific journals are usually printed by offset rather than by a line plate, since such a large line cut would cost considerably more than the same size offset plate.

Collotype.—Among reproduction processes commonly used

in scientific journals the finest reproductions of photographs and toned drawings are made with collotype, or photogelatin, plates. The original is photographed without a screen, and the negative is printed on a gelatin film. This film is hardened chemically and fastened to a metal plate. Not so many copies can be made from a collotype plate as can be printed from a photoengraving or offset plate, but the results are very fine. This is the most expensive of all the processes mentioned.

Color Reproduction

Reproduction in color is considerably more complicated and costly than reproduction of black-and-white illustrations, but the same basic methods of printing are used in letterpress photolithography and gravure reproduction of color or monochrome.

In the preparation of a color reproduction, several halftone negatives are made from the original. Each of these is made with a different color filter between the camera and the illustration, so that only light of a particular chosen color registers on each black-and-white negative. The engraver then makes plates from these negatives as he would for black-and-white reproduction. The result is a set of plates each of which will print only that part of the original illustration in the particular color registered.

The color of the original illustration is thus separated into component parts by the engraver, and it is the task of the printer to reassemble these individual colors into a full-color reproduction. He does this by printing each of the plates in ink of the appropriate color, superimposing the images on the single sheet of paper. The resulting blend of inks of several different colors effectively reverses the separation performed in making the plates and produces an illustration reasonably faithful to the original. Of course, the reproduction is not

limited to the few colors in which the plate is printed but, owing to blending, shows many other hues as well.

Most color printing is done in a four-color process. Four plates are made and printed in black, magenta, cyan blue, and yellow. A less expensive and less satisfactory process eliminates the black, and for highest-quality printing as many as six or eight colors may be used.

Color reproduction is expensive compared to black-and-white reproduction because of the many extra steps in each job. Several plates rather than one must be made. Each sheet must be run through the press a number of times instead of once. Careful attention on the part of the printer is required in the selection of inks. He must also be certain that the several plates are printed precisely on top of each other, or the images will be out of register, and the final plate will appear out of focus. This is perhaps the most common fault found in color reproduction.

Color originals may be prepared from opaque originals (such as paintings) or from film transparencies. Manufacturers of different brands of color films use different dyes to produce similar results; if an author wishes to illustrate his work with reproductions of colored slides, he does well to limit himself to a single brand of film. When different films are involved, the printer may have to use compromise inks for similar colors or adopt the expensive alternative of using extra inks and extra printings.

Selected References

FLADER, LOUIS, and MERTLE, J. S. *Modern Photoengraving*. Chicago: Modern Photoengraving Publishers, 1948.

SKILLIN, MARJORIE E., GAY, ROBERT M., and OTHERS. *Words into Type*. New York: Appleton-Century-Crofts, Inc., 1948.

2 SIZE AND REDUCTION OF ILLUSTRATIONS FOR PUBLICATION

Advisability of Reduction

Ordinarily, illustrations—photographs as well as drawings—are reproduced smaller than the original illustration. There are sound reasons for reducing illustrations in final reproduction. The artist is permitted to work in a conveniently large size, so that he may draw detail more easily. Also, slight reduction of the original will minimize small imperfections of line and increase the sharpness of the illustration in general. This does not mean that the artist should rely on reduction to make his work satisfactory; true, slight reduction may improve a good picture, but nothing short of burning will help a poor one.

Planning the Copy Size

The amount of reduction the illustration must undergo will depend on how large the artist likes to work, on how much detail and fine drawing are included in the picture, and on what the editor of the publication decides. In general, a reduction of one-half is desirable, because it cleans the line work without loss of detail. Some editors and printers prefer a one-third reduction, however.

To prepare an illustration for a one-half reduction, the artist should draw exactly twice as large as he wants the printed result to be. For a one-third reduction the original should be one and one-half times as large as the print will be.

When giving reduction directions, the illustrator must be careful that he understands the directions he is giving. "Re-

duce one-half" means the same as "One-half off" or "Reduce to one-half"; the final size would be one-half the dimensions of the original drawing, or one-fourth the original area. "Reduce one-third" and "One-third off" do *not* mean the same as "Reduce to one-third." A drawing measuring 3 by 6 inches would measure 2 by 4 inches if the reduction directions read "Reduce one-third" or "One-third off"; the same drawing would measure 1 by 2 inches if the directions read "Reduce to one-third." The wording of the reduction directions therefore must carefully be checked.

reduce line to 4 inches

Fig. 5.—An acceptable method of indicating the amount of reduction desired. The figure is reduced one-half from the Ross board and wax-pencil rendering of a tadpole of a narrow-mouthed frog, *Microhyla mazatlanensis*. (This figure and all figures following except Figures 59–62 are reproduced by offset.)

Reduction directions usually are indicated on the margin of the illustration in blue pencil. If the illustration is not to be reduced to a convenient fraction of its original size, the directions may read "Reduce to *x* inches" along a line drawn in the appropriate margin. (Only one edge need be marked, since the proportions remain constant in reduction.) Some editors prefer that the reduction be stated in terms of printer's linear measure, points and picas, rather than inches. Six picas equal 1 inch, and 12 points equal 1 pica. An example of a reduction direction properly given is shown in Figure 5.

If at all possible, the artist should know before beginning work on an illustration in what journal it is to be published.

He will be able to measure page size and study the format of the publication and thus know what some of the size limits placed on the published illustration will be. In publications with a two-column format, considerations of cost may require that figures be reduced to the width of a single column. A frequent result is that an otherwise adequate illustration is rendered virtually useless through the loss of detail occasioned by too great reduction. If the artist is aware beforehand of the published size of the final result, he will be able to tailor the size and detail of the original to the restrictions imposed by the medium of publication.

A professional editor can be expected to require that illustrations accepted for publication are adequate for the method of reproduction to be employed. Unfortunately, the editors of most scientific publications are not professionals and usually have that task as an unremunerated addition to numerous other academic and scientific duties. They often lack both the time and the ability to evaluate properly the illustrative material that passes through their hands. It then becomes the responsibility of the artist to see that the illustration is proper in all respects for the method of reproduction and size of illustration to be employed. Some journals make available to contributors a manual or pamphlet in which the preferred style of illustrative material is detailed.

In determining the size of a proposed illustration, the artist must remember to make allowance for the legend. In an imaginary case the allowable plate measurements are 6 by 8 inches. Two lines of legend will occupy one-quarter of an inch (the amount of space per line of legend will, of course, vary with the size of type used in the journal), thereby subtracting that amount of space from the 8 vertical inches available for the plate. Since a one-half reduction is desired in this hypothetical case, the working size will be twice the final measurements, or 15½ by 12 inches. One way of planning the

working size (see Fig. 6) is first to draw a rectangle of the reduction size (rectangle *ABCD*), extending side *AD* to twice its length, making line *DAE*. Side *DC* is also extended. A diagonal line is drawn from *D* to *B* and extended beyond *B*. At point *E* a horizontal line is drawn to intercept the diagonal at point *F*, and from this point a perpendicular is dropped to

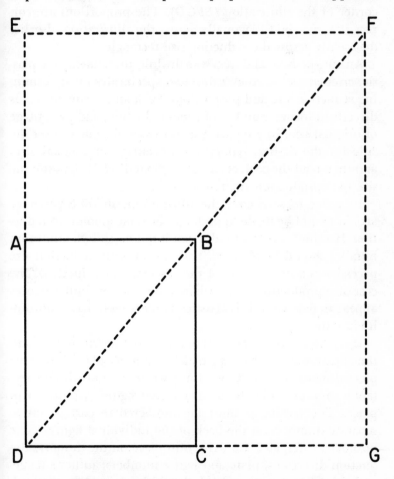

Fig. 6.—Diagram of method of planning copy size and reduction size

point G. The proportions of the new rectangle (*EFGD*) are the same as the proportions of the original rectangle, but the new rectangle is twice the size of the original.

This diagram is a convenient method of checking the proportions of the finished original against the desired reduction size. A tracing of the reduction size (*ABCD*) is placed in one corner of the illustration (*EFGD*). The proportions are correct if a rule laid diagonally across the illustration also lies diagonally across the reduction-size rectangle.

An inexpensive and very worthwhile investment is a plastic, circular "slide rule" calibrated specifically for determining reduction size and proportions. Such an instrument reads directly in inches, number of times reduction, and percentage of original size. In a typical use, for example, one can set the rule for the desired reduction (percentage of original size) and then read the correct size of original directly opposite the size of reproduction desired.

In order to save cost, the illustrations for one paper or article should be made to undergo the same amount of reduction. If a single uniform reduction is not possible, a minimum number should be planned. Each variation in reduction size necessitates a new setting of the camera, which increases the cost of reproduction. Also, where a number of similar figures appear in one work, it is artistically pleasing to have continuity in lettering size.

If the figures on a plate are to undergo different reductions, the illustrator will have to make a dummy plate. The true plate dimensions are drawn on a white cardboard, and rectangles representing the final, reduced figures are drawn in place. The rectangles must be numbered to correspond to separate numbers on the back of the individual figures. The numbers, titles, etc., are written in place on the dummy. Reduction directions, plate and figure numbers, author's name, and title of the paper or book should be written on the back

of each illustration, all of which are then put in an envelope attached to the dummy plate.

A reducing lens is an invaluable aid when working on any illustration which is to be reduced in publication. By viewing the illustration through this lens from time to time while working, the artist will be able to judge better how heavy to draw his lines, how much darkness to use in a shaded area, how detailed he may draw, etc. But, though he can get an idea of the final reduced illustration by using a reducing lens, the artist must remember that the printing process tends to make lines appear thicker and more closely spaced than the view through the reducing lens suggests. For this reason it is wise to draw in a more open manner than is actually desired for the printed result. Lines and dots should be farther apart, and shadows should not be quite so dark in the original as they are wanted to appear in the printed version.

Selected References

RIDGWAY, JOHN LIVESY. *Scientific Illustration*. Stanford, Calif.: Stanford University Press, 1938.

3 *MATERIALS*

The illustrator should see that he is properly equipped with the materials he will need before beginning to draw. Basic and special materials are listed below under the techniques in which they are used. Note that several items appear under more than one heading. Some items are optional, and their purchase will be dictated by individual need and preference.

Rough Drafts and Pencil Drawings

Lead pencils ranging in hardness from 4B to 6H.

Artgum or soft rubber eraser.

Kneaded (charcoal) eraser.

Inexpensive sketching paper, such as newsprint or bond.

Good-quality drawing paper: kid-finish Bristol board, two-ply plate-finish drawing paper, or illustration board.

Sandpaper for sharpening pencils.

Ink Renderings

Several straight penholders.

Pen points of various sizes and degrees of flexibility, including fine mapping points, crow-quill pens, and writing and lettering points.

Black waterproof drawing ink.

Waterproof colored drawing inks if working in color.

Glass eraser for removing ink lines and a piece of pumice to smooth the roughened paper surface.

Carbon tetrachloride or a kneaded eraser for removing pencil lines from inked renderings.

Chamois or lintless cloth for wiping pen points.

Good-quality drawing paper: Bristol board, two-ply plate-finish paper, or illustration board.

Scratchboard Drawings

Fine and medium watercolor brushes.

Medium-fine and medium-coarse pens.

Waterproof black drawing ink.

High-quality scratchboard, such as Essdee British scraper board, or acetate or polyester film.

Scratchboard tool, such as No. 1 X-acto knife and several blades.

Stiff mounting board, such as poster board.

Dry-Brush Renderings

Round and flat watercolor brushes.

Textured ground, such as watercolor paper or illustration board.

Waterproof black drawing ink.

Charcoal Renderings

Sticks of charcoal—hard, medium, and soft.

Kneaded eraser.

Chamois.

Charcoal paper.

Sandpaper for sharpening sticks.

Black-and-White, Using Special Grounds

Coquille board.

Ross stipple board.

Medium-hard lithographic pencil or black china marking pencil for use with above grounds.

White gouache paint.

Scratchboard tool (with Ross board).

Wash Drawings

Round and flat watercolor brushes.

Pens.

Waterproof black drawing ink or black watercolor or an ink block.

Cup or dish for mixing wash.

Watercolor paper or illustration board.

Watercolor Paintings

Round and flat watercolor brushes.

Watercolor paper or illustration board.

Pan or tube transparent watercolors.

White saucer or pan for mixing paints.

Stiff board and gummed-paper tape for stretching paper.

Gouache Paintings

Round and flat watercolor brushes.

Illustration board.

Gouache paints (also called "poster paints" or "designer's colors").

White saucer or pan for mixing paints.

Casein or Oil Paintings

Casein or oil paints.

Round, flat, and bright oil brushes.

Turpentine and linseed oil for oil paints.

Canvas, imitation canvas, or gesso panel.

Mixing pans.

Palette.
Palette knife.

Maps and Graphs

Inexpensive graph paper.
Good-quality graph paper printed in light blue.
Hard pencils.
Waterproof black drawing ink.
Leroy socket-holder and several sizes of points or a ruling pen.
Rules—inch and/or metric scales.
Curved rule.
Triangle or T-square.
Stencil with different sizes of circles, squares, and triangles.
Soft rubber and kneaded erasers.
Shading films, such as Zip-a-Tone or Craftone.

Lettering

Lettering pens or a lettering device, such as the Leroy and Wrico lettering systems.
Waterproof black drawing ink.
Long rule.
Hard- and medium-lead pencils.
Soft rubber or kneaded eraser.
Graph paper or two-ply plate-finish drawing paper.

Retouching and Drawing over Photographs

White conte pencil.
Soft- and medium-lead pencils.
Charcoal pencils.
Sandpaper for sharpening pencils and charcoal.
Round watercolor brushes.
Black and white gouache paint.

Krylon dulling film or Copy-Zip matte transparent film.
Photographic retouching dyes.

Mounting Illustrations

Masking tape.
Rubber cement.
Dry mounting tissue.
Mounting board, such as poster board.
Brown wrapping paper.

Miscellaneous Materials and Equipment

Below are listed some miscellaneous and special materials
and equipment which may be useful, depending on their
availability, the amount of illustrating to be done, and the
resources of the artist.

Tracing paper, tracing linen, or acetate film
Tracing table
Drafting tape
Reducing lens
Calipers
Small forceps
Simple dividers
Proportional dividers
Pantograph
Camera lucida
Microscope camera lucida
Telescope
Grid-scored plastic for use with telescope
Ocular reticule and/or micrometer
Baloptican projector
Microprojector

Selected References

ARTHUR BROWN AND BRO. *General Catalog of Artists' Materials,
Drawing and Drafting Supplies.* New York: Arthur Brown &
Bro., Inc., 1958.

MAYER, RALPH. *The Artist's Handbook of Materials and Tech-
niques.* New York: Viking Press, 1940.

4 DRAWING

Introductory Remarks

The purpose of a biological illustration is to clarify or demonstrate what is contained in the written work. In order to accomplish this end, the illustrator must keep in mind several guiding principles which are applicable to all biological illustrations executed in any style or medium.

Observation.—The most important quality in a scientific artist is a well-developed power of observation. Faulty observation, which leads to faulty illustration, usually is caused either by a lack of understanding of the subject or by too much understanding. Happily, the first cause is often corrected by the attempt to draw the object, which leads to further study and knowledge. The second source of trouble—too much understanding—is not so easily recognized or corrected. In this instance the artist tends to represent what he knows about the object or what he believes to be true rather than what actually exists. In such a circumstance the artist needs a new perspective, which may be gained by examining the subject in an unfamiliar position, such as upside down or reflected in a mirror.

Crowding.—The illustration must be neat and complete but not overcrowded. It is unwise and wasteful to include more detail than actually is necessary. The purpose the illustration is to serve, or the persons who are to use it, will determine how detailed the work should be. A rendering of a type specimen, for instance, might be drawn in full detail, whereas the major differences among several genera may be illustrated

more advantageously by a series of simple line drawings. The artist should not try to include too much information in his illustration, or he may succeed only in confusing the viewer. A graph with a great many lines may be quite useless, and a drawing so detailed as to disperse attention from or disguise the important point is worse than useless. An illustration prepared for use in a high-school textbook might differ in detail from one intended for publication in a scientific journal.

Emphasis and comparison.—The illustrator often has an inclination to exaggerate a point under discussion, but this may lead to a false impression and should be avoided. By use of special techniques, prominence may be given certain features and thus capture attention without distortion. In drawing comparison between two or more subjects, the illustrator should emphasize differences not through exaggeration but through accentuation by darkening lines in critical areas and by using shading and highlights which will throw these areas into relief.

Shading convention.—There exists a shading convention in scientific illustration. In general, a drawing is shaded as if the light source (or principal light source) were placed out of the upper left corner of the picture. This convention serves three purposes: this is a common position of the actual light source when one is comparing a specimen with an illustration; there should appear to be a common light source for several different illustrations which may be grouped together on one plate; and it is much easier to compare drawings by different artists if the light source appears to be the same in all drawings. Occasionally, special lighting is required to emphasize some particular detail, in which case the shading convention is recognized for what it is—a convention, not a law.

In general, double lighting of an object is desirable because it makes the picture more interesting in value and form and keeps it lighter than would a single source of illumination. A

dark drawing does not reproduce as well as one lighter in tone. The second light source is not so strong as the principal one and may be placed wherever the artist chooses.

Perspective.—By "aerial perspective" is meant the artistic expression of space by loss of definition, value range, and color warmth, which is due in nature to intervening atmosphere between the observer and object. The greater the distance, the more obvious these effects will become. This can easily be demonstrated by pretending to move away from nearby mountains. At close range the canyons and crags, the pattern of highlights and shadows, and the warm and varied colors can be seen. As the observer moves away, the mountains gradually lose their ruggedness, the value pattern becomes one continuous tone, and the colors become cooler. From a great distance the mountains look flat and textureless, with no range in value, and the color is uniform violet or blue.

Showing aerial perspective in black-and-white drawings, then, is not at all difficult. The nearer parts are given the deepest shadows and lightest lights, the most detail, and the heaviest outlines. Even simple line drawings will exhibit a three-dimensional effect if the heavier lines are used to draw the closest parts. Another means of showing perspective is to break the line of the distant part which passes under or behind a closer part just at this junction (see Fig. 7). The greater the distance between the two parts, the greater should be the break in the line.

Objects in space appear to change in size as they recede, parallel lines seem to converge, and horizontal lines do not remain horizontal. Drawings, to be convincing to the viewer, must at least approximate these conditions. To do this, the artist applies linear perspective. Ordinarily, the biological illustrator will not be required to produce an elaborate picture such as a landscape, which will require the use of linear

perspective. If a knowledge of linear perspective is necessary, the illustrator should refer to textbooks. (One good reference is Mayer [1940], pp. 421–32.)

Cleanliness.—It behooves the illustrator to keep his work as clean as possible. Dirt and smudges may reproduce photographically. If such marks cannot be erased satisfactorily, they should be covered with white gouache (poster paint) or with strips of white paper pasted over the area. One way to keep

INFRAORBITAL
FORAMEN

FORAMEN
MAGNUM

Fig. 7.—Example of aerial perspective in a simple line drawing. Note the broken lines where one part of the skull passes behind a closer part. Note also the treatment of the arrows within the drawing and the placement of the labels. The original drawing (skull of a giant rat, *Xenuromys barbatus*) was done on scratchboard and was reduced one-third in publication.

the work free of dirt is to place a sheet of clean paper between the hand and the drawing while working.

Allowable latitude.—The latitude allowable in scientific illustration may permit the artist to deviate somewhat from absolute precision except in significant details. For example, the outline of a skull may be drawn in a free manner, while a certain feature of that skull which is being discussed must be rendered in absolute detail. The purpose which the illustration is to serve also may determine the latitude permitted. A picture used as an embellishment or to show an animal in general will not be drawn so precisely as an illustration of a

particular structure in a particular specimen. Common sense will tell how much freedom may be exercised.

Artistry.—The illustrator will find it to his advantage to study drawings by other artists. He must determine how much detail to include and how much he may leave out for the most effective illustration. He should be cautioned against that most common pitfall—overworking the drawing. Enough is good; a little more may ruin the picture.

Every effort should be made to produce a picture which is artistically pleasing as well as biologically correct. Lifelike posing of live subjects and at least graceful positions of dead ones are essential. Often a plain outline drawing may be made more interesting to the observer merely by adding a background line to suggest the horizon; this will give depth to the picture. The use of shading film (Zip-a-Tone, for example) around the simply drawn subject may seem to lift the subject from the paper surface (Fig. 18). Such devices may be used tastefully to liven a good drawing.

Measuring the Subject, Using Common and Special Drawing Aids

Large objects may be defined as those which can be seen clearly and in sufficient detail with the unaided eye. Small objects are those which, while not microscopic in size, are so small that some degree of magnification is necessary in order that the detail of the object may be perceived by the artist. Microscopic objects are of a size that considerable magnification (as with a compound microscope) is essential in order that detail may be observed.

Measurements and proportions.—Before beginning to draw, the illustrator will have determined the dimensions of the drawing to allow for the reduction in publication (see chap. 3). Unless a special technique, such as the use of the telescope (see below), is employed, it will be necessary to measure the

subject of the illustration and adjust the measurements to suit the desired reduction or enlargement of the drawing. Convenient instruments, in addition to the familiar rule for making measurements, are calipers, dividers, and proportional dividers. Commonly, calipers are available with a maximum linear measuring distance of 6–8 inches, although larger tools are made. Measurements may be made directly from calipers,

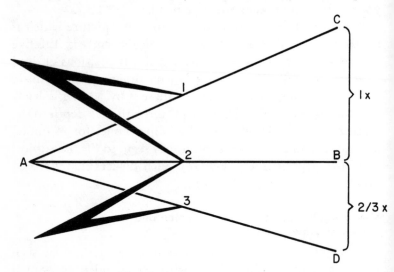

FIG. 8.—Method of enlarging measurements taken with simple dividers

whereas a measurement laid off with dividers must be read by resting the tips of the dividers against a scale. In using either of these instruments, the final reduction or enlargement in the illustration is determined by multiplying the measurement of the object by the reduction or enlargement factor. This may be done arithmetically, or the illustrator may employ a graphic method such as is described in the following paragraph.

On a piece of graph paper draw a horizontal line (Fig. 8, *AB*). Erect a perpendicular at *B* equal in length to the largest

measured dimension of the object (Fig. 8, *BC*). Erect another perpendicular (*BD*) that bears the proper multiple of *BC* to agree with the desired proportional change in the drawing. Now, in order to convert any measurement of the object to the proper corresponding dimension in the drawing, it is merely necessary to lay that measurement off on the graph perpendicular to *AB*, as at *1–2* (Fig. 8), and read the new dimension opposite, as at *2–3*.

By the use of proportional dividers, an artist may eliminate the necessity of arithmetic or graphic calculation of dimensions for the final drawing. Proportional dividers (Fig. 9) consist of two legs, pointed at both ends, on an adjustable, sliding

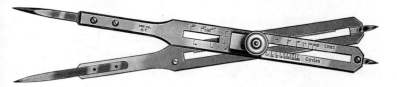

Fig. 9.—Proportional dividers. (Courtesy Keuffel & Esser Co.)

pivot. The dividers are set so that the distance between the points at one end will bear the desired proportional relation to the distance between the points at the other end. With the pivot locked in place, the proportions remain the same with the dividers open or closed. Thus, if the instrument is set to multiply a linear measurement of two and one-half times, a measurement of 6 millimeters taken at the smaller end will measure 15 millimeters at the larger.

The illustrator should "block in" the outline of the object being drawn. If he wishes to draw twice natural size, he draws a box measuring twice the length and twice the width of the actual object. Within the box, he marks off various reference points, such as half the object length, one-quarter object length, length from posterior margin to a particular feature,

and other similar points (Fig. 10). It is unwise to add together separately measured parts of the subject to compute the total length, for the accumulation of small errors in measurement may make a large error in the over-all length. It is better to take all measurements starting from one end of the subject.

In drawing bilaterally symmetrical objects, the artist can save time and effort by drawing only one-half. The drawn half is then traced and transferred to the mirror-image position of the drawn half. Careful measurements must be made to assure that the transferred drawing is accurately placed.

There are several difficulties encountered when attempting to measure a three-dimensional object for a two-dimensional illustration. Biologists unfamiliar with problems of illustrating may assume that exact measurements can be taken from the drawing itself, without considering the foreshortening that is bound to occur in making the drawing. All measurements should be taken in the same plane in order to make an illustration of *what is seen*. In Figure 11, line AC represents the picture plane, or plane of measurement for the top, and line AD the plane for the end view of the shell. It is obvious that measurements not in the picture plane do not remain proportional in the drawing because of curvatures of the shell and relative distances from the plane of measurement. Therefore, in the finished rendering of the shell's top view, actual distance EB would be represented as distance AB. Another difficulty is deciding whether to keep the eye stationary above the object, which will introduce the effect of parallax into the drawing, or to move back and forth, which will necessitate juggling several measurements so they will fit into the actual length measurement. The second method generally is preferable, but the most satisfactory results are gained by using the telescope.

Use of the telescope.—Obviously, it would be most desirable to eliminate the effects of parallax on the object. The farther

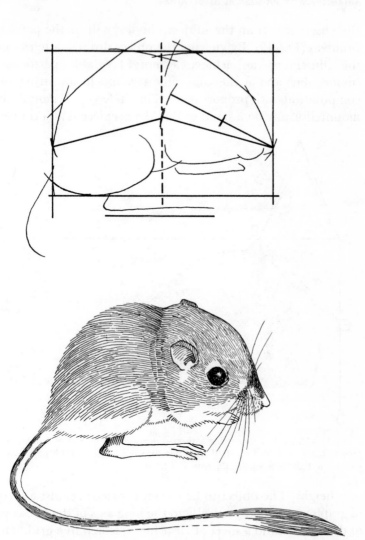

Fig. 10.—Method of blocking-in a drawing. Reduced one-third from pen drawing of a kangaroo rat, *Dipodomys merriami*. Note also the fur technique.

the observer is from the subject, the less will be the parallax problem (Fig. 12). By viewing the object through a telescope, the illustrator can achieve a more favorable perspective (monocular) and at the same time save much measuring and computation of proportions. The telescope should be mounted firmly on a stand so that the eyepiece is at a conven-

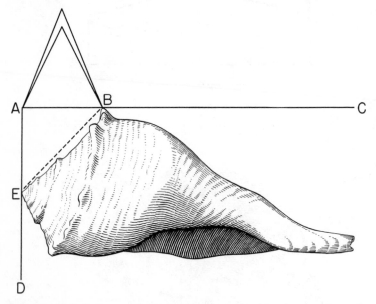

Fig. 11.—Method of measuring a three-dimensional object in one plane—the picture plane. Reduced one-half from pen drawing on plate-finish paper. Subject is the lightning whelk, *Busycon sinistrum.*

ient height. The object to be drawn is placed against a piece of graph paper held vertically to the long axis of the telescope or directly behind a sheet of clear lucite scored in a grid. The illustrator then views the object through the telescope and draws on a piece of graph paper. The object-grid and the drawing-paper-grid co-ordinates are keyed with letter and number series in vertical and horizontal directions so that a

point on the object grid can be duplicated with a corresponding point on the drawing-paper grid. Using the appropriate co-ordinates, the features of the subject as seen through the telescope can be transferred to the drawing paper with a minimum of perspective distortion. The degree of reduction or enlargement of the object is determined by the ratio of object-grid size to drawing-paper-grid size (see Fig. 13). The use of this simple procedure has proved invaluable in saving time and achieving accuracy.

The camera lucida.—This instrument consists in essence of a four-sided glass prism mounted on a stand which holds the

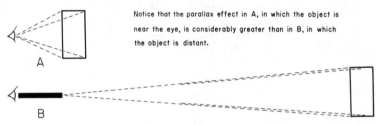

Notice that the parallax effect in A, in which the object is near the eye, is considerably greater than in B, in which the object is distant.

A

B

Fig. 12.—Diagram of the parallax problem. Notice that the closer the eye is to the subject, the more evident is the parallax.

prism above the drawing paper. The reflected image of the object to be drawn appears to the artist to be projected on the paper. When the pupil of the eye is held half over the edge of the prism, the observer sees the image of the object with half the pupil and the drawing paper with the other half (Fig. 14). This simultaneous viewing of drawing paper and object image allows the artist to trace the outline of the image with fidelity.

Since the eye cannot focus on the paper and pencil at one distance and the object image at a different distance at the same time, the object must be placed the same distance from the prism as the prism is from the drawing paper. This will result in a drawing the same size as the object. In order to

A HANDBOOK OF BIOLOGICAL ILLUSTRATION

produce a drawing of different ratio to object size, the object must be moved closer to or farther from the prism. In this event a plus or minus lens is placed in front of the prism in order to correct the focus so that the image may be traced. If the image is not properly focused on the paper, the pencil point will appear to "crawl," and eyestrain and errors will result.

Proper alignment of the paper, prism, and object is neces-

Fig. 13.—Method of using co-ordinate squares to copy a drawing or to change the size of a drawing.

sary if distortion is to be avoided. In order to check align-
ment, the illustrator mounts a small square or straight-sided
object in the place to be occupied by the object to be drawn.
If the image shows only the end of the test object, alignment
is proper. If, however, the image is off-center so that a side of
the test object shows, it must be shifted until only the top
appears. The possibility of distortion in a camera lucida

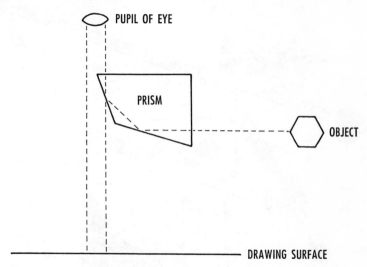

Fig. 14.—Principle of the camera lucida

drawing is high, and the artist must take special care to pro-
duce a drawing of proper proportions.

Ease of operation of the camera lucida depends in part
upon proper lighting. Lighting of the object and drawing
paper must be balanced so that the image is bright enough to
be seen easily yet not so bright as to obscure the drawing
paper and pencil.

The pantograph.—With the pantograph (Fig. 15), the user
follows an outline with a scriber point while a graphite point
mechanically traces the same course to a predetermined scale,

larger or smaller. When a two-dimensional subject is copied, the scriber point contacts the subject, and there is no problem of parallax. The pantograph may be used to copy three-dimensional subjects, but, since the scriber point travels in only one plane (with the graphite point), it is evident that the point cannot contact varying levels of a three-dimensional ob-

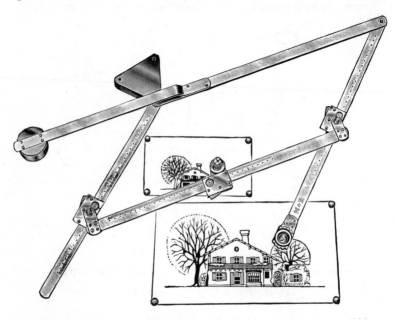

Fɪɢ. 15.—Pantograph. (Courtesy Keuffel & Esser Co.)

ject. The point must travel in a plane above the subject being copied, and the operator must keep the scriber point exactly vertical above the point on the object being traced. This is difficult to do unaided, especially if the object has much depth. One solution is to mount a "sight," such as a vertical tube of small bore, on the scriber point. Looking down the tube at the object will eliminate the problem of parallax. In working with three-dimensional objects, it will, of course, be

necessary to place the object at a lower level than the table on which the pantograph rests.

Photography.—An accurate outline for a subject may be obtained by photographing the subject, enlarging or reducing the photograph as desired, and then tracing or "drawing over" the photograph (see chap. 7).

Microscopes.—A dissecting binocular microscope (also called a "stereoscopic microscope") will be useful for seeing and drawing small specimens. The outline may be sketched by means of the telescope and the details filled in under the microscope; or, if the specimen is small enough to fit entirely within the microscope field, both outline and details may be drawn while viewing the object through the microscope. The object under the binocular microscope should be viewed with only one eye for drawing in order to see it without the problem of perspective. It will be necessary to prop the object slightly on an angle so the plane of view will be at a right angle to the object plane for monocular viewing.

A compound microscope is used to see and draw objects not discernible with the naked eye. A scanning lens is used to locate the portion of the slide to be illustrated; lenses of greater magnification then are used to see the desired part in greater detail. Filters of different colors used with the microscope will enable the illustrator to see certain particulars more clearly by bringing out one stain while subduing others.

An ocular micrometer or, preferably, a grid-ruled reticule which fits into the ocular of either a binocular or a compound microscope will enable the artist to draw accurately by using the grid-co-ordinate method as described on pages 34–35.

To determine the magnification of the object drawn under the dissecting microscope, the illustrator divides the total length of the object into the total length of his drawing. The artist may determine the magnification of a microscopic object by using a precalibrated ocular micrometer and compar-

ing the measurement made with the ocular with the corresponding measurement of the drawing. Another method of determining size and magnification of microscopic objects utilizes a scale constructed by using a stage micrometer and a microscope camera lucida. The micrometer scale is focused in the microscope field and its image traced on a piece of paper by means of the camera lucida. An image of the specimen can, with the aid of the camera lucida, then be superimposed on the drawn scale and the specimen measured. Care must be taken so that the same magnification is used in making the scale and measuring the drawing of the specimen. The magnification of the drawing can be found by simple arithmetic. For example, suppose the drawn specimen measures 6μ on the drawn scale and 3 centimeters by actual measurement with a metric scale. Knowing that 3 centimeters are equal to $30,000\mu$, one divides 6 into 30,000 and finds that the specimen has been enlarged five thousand times in the drawing. In passing, it is worth noting that reduction of magnification when a drawing is reduced in publication must be taken into account when preparing a figure legend.

If the illustrator wishes to draw to a scale which he cannot obtain by using a microscope, he may complete the sketch at any feasible magnification and then enlarge or reduce this drawing by means of a Baloptican projector (Fig. 16) or by photographing the sketch. As in redrawing or tracing, the artist must check the final sketch for accuracy and liveliness of line which may have been lost in the tracing.

Microscope camera lucida.—This is a device attached above the eyepiece of a microscope that, by means of a broken-beam prism and a mirror, enables the artist to see the specimen through the microscope and at the same time see an image of the specimen apparently projected on a sheet of paper. The image of the specimen is traced by following the movement of a pencil point on the drawing paper while looking into the microscope. By varying the objective and eyepiece magnifica-

tions, the image can be made larger or smaller as desired. The cautions about properly balanced lighting and alignment of elements made concerning the camera lucida (pp. 36–37) also apply here. The angle of the mirror is checked by placing a

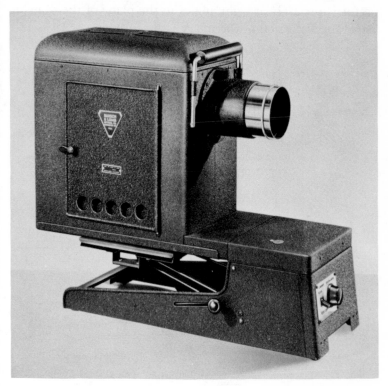

Fig. 16.—Baloptican projector. (Courtesy Bausch & Lomb Optical Company.)

small cube or cylinder (end up) on the drawing paper and manipulating the mirror until only the end, not the sides, of the test object is seen.

Microprojector.—The microprojector, which commonly is used to project microscope slides for viewing, may also be utilized for making drawings of slide-mounted subjects (Fig. 17). Drawing will be facilitated if the projector can be directed

downward onto a drawing surface and can be mounted on a stand that will allow the distance of the projector from the paper to be varied according to the degree of magnification desired. One must be sure that the optical axis of the projector is precisely at right angles to the plane of the drawing paper, or distortion of the image will result.

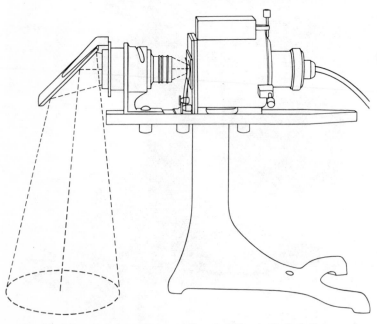

FIG. 17.—Microprojector. (Courtesy Bausch & Lomb Optical Company.)

Supporting an object for drawing.—When drawing an object, the illustrator often will find that the desired position of that object is not one in which it will readily remain without support. A convenient method of holding many kinds of objects stationary is to mold a support of oil clay or Plastacine. The clay is softened and shaped by squeezing it between the fingers, and the specimen is pressed into position on the clay.

A neutral clay is best, as colors may cast undesirable reflections or stain the specimen. Heat softens the clay and may cause it to cling to the object, so it is important that sources of excess heat, such as lamps, are not too near the clay. If oil clay is unavailable, paper towels may be substituted. These are soaked and then crumpled into a more or less solid mass and allowed to dry in the desired position.

Drawing Live Animals

Occasionally, the illustrator must draw from live animal models. Live models present many difficulties, the chief of which is motion. As in any drawing from nature, the artist must spend at least as much time observing the subject as he will spend drawing it. Sitting quietly near the animal for a half-hour or so will enable the artist to observe its form and manner of movement; also, it will give the animal a chance to become accustomed to the perhaps unfamiliar presence of the illustrator.

It may be necessary to anesthetize the subject in order to keep it quiet enough to sketch, though one must be careful that unnatural posture is not introduced. Amphibians and reptiles may be chilled into quiescence by placing them in a refrigerator for a short time; carbon dioxide will anesthetize insects without permanently harmful results if not applied for too long a period; a small amount of chloroform will make some animals drowsy, and merely feeding others will calm them. Birds may be kept in the dark until they are needed for actual drawing; usually the sudden light will serve to keep them quiet for a time.

Special pens and cages may be built or improvised for immobilization of live animals. The material of the cage must not hide the animal; one side constructed of glass or lucite may be sufficient. Small aquariums and wide-mouthed glass jars covered with hardware cloth may be used successfully as

cages. Generally speaking, the animal should have enough room to turn around and assume a comfortable position without being cramped or allowed to roam. Precise details may be studied while the animal is more closely confined. Some lizards and snakes may be held in one hand while sketched with the other, but small mammals are likely to bite unless held in a manner that prevents close scrutiny. Wide-mouthed quart and gallon jars and small aquariums will hold such animals for precise observation and drawing of details.

Subdued or colored lights may be useful when one attempts to study and depict nocturnal animals and their behavior.

In order to capture the peculiar characteristics of the animal to be illustrated, the artist should make many sketches from all possible angles. He should begin by blocking-in the simple form, adding detail and shading later (Fig. 10). Blocking-in and measuring the animal by head lengths are useful short-cut techniques. The head, eyes, feet, and other particulars should be practiced from different angles. Only after a great deal of quick sketching will the artist be familiar enough with the subject to make a creditable drawing.

Fur resembles masses with soft outlines. It should not be drawn as a confusion of lines. Occasional hairs may be suggested, but the illustrator must not become so involved in representing individual hairs that he loses the form and character. Coquille board and Ross stipple board may be used to draw soft fur; individual hairs may be suggested on the Ross board by scratching with a knife. Only the outlines of feathers are seen from a short distance, and even these outlines disappear as the bird recedes from the observer. Scales may be suggested in medium-value areas and not depicted at all in highlights and shadow areas unless the scale pattern is the important part of the illustration.

Black-and-White Line-Cut Illustrations

Planning and transferring the drawing.—The drawing is planned in medium- to soft-lead pencil on lesser-quality paper. The values should be carefully executed in the rough drawing, which is then transferred to the final on good-quality drawing paper. There are several methods of transferring the pencil sketch. One way is to trace the sketch, ink the tracing, and then blacken the back of the traced lines with a soft-lead pencil. The tracing is placed blackened side down on the good paper, and the lines of the drawing are retraced with a sharp-pointed, hard-lead pencil. The blackened side of the tracing acts like carbon paper but is much safer to use, since typewriter-carbon marks are difficult to erase.

Another method of transferring is to blacken the back of the original sketch. This is simpler than the tracing method but is not so desirable if one wishes to save the original sketch. If a good-quality tracing paper is used, the ink rendering may be done completely on it and the finished work mounted firmly on stiff white board. Tracing linen often is used in this manner. Sheets of clear acetate or polyethylene which are frosted on one side also may be used and will take ink quite well.

A tracing table will enable the illustrator to trace a sketch with a minimum amount of trouble. The tracing table consists of a sheet of frosted glass placed over a shallow box containing one or several lights. If these lights are bright and the copy clear, the illustrator will be able to use bond or even two-ply drawing paper as the tracing sheet.

Pen-and-ink drawings.—The final paper should be of good quality. Kid-finish Bristol board, two-ply plate-finish Strathmore drawing paper, and kid-finish illustration board are all recommended. Good-quality tracing paper, tracing linen,

and acetate sheets, as mentioned above, also may be used.

The artist should have several straight penholders and a supply of pen points of various sizes and shapes, a bottle of waterproof black drawing ink, and a piece of chamois.

Each person will develop his own particular method of drawing; there are no fast rules to follow. Some methods of

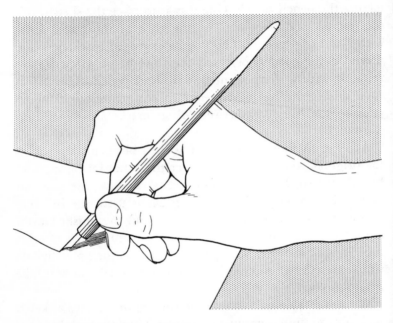

Fig. 18.—Correct position of the hand holding the drawing pen. The background is Zip-a-Tone.

using the pen, however, are better than others in obtaining good results. If the pen is held too loosely or too tensely, or if the pressure is greater on one nib than on the other, or if the point is at too acute an angle to the paper, the resulting line will be ragged and blotchy. Firm but not excessive pressure and a wide angle between the pen and the paper (Fig. 18) will aid in drawing smooth, clean lines. A new pen

point may need to be prepared for use by drawing for a few minutes on scrap paper or by holding it briefly in the flame of a match. The pen should be wiped at frequent intervals on a chamois while one is working, as a pen stuck with drying ink cannot produce a fine, clean line. Dried ink should be removed by scraping the pen with a knife blade or scratchboard tool.

The pencil outline on the inking (final) paper is the basis for the ink rendering. In biological illustration an outline is generally employed to separate the subject sharply from the background. The line should be varied in width, to add interest and give emphasis. This may be accomplished by using a flexible drawing point and varying the pressure. If no drawn outline is to appear in the ink rendering, the shading lines or dots are drawn to the penciled outline. Figure 19 shows examples of subjects drawn with and without outlines.

A line should be begun at a natural starting place, such as a corner or junction of two lines. The illustrator should not lift the pen from the paper until the next junction or angle in the line. If for some reason he must break the drawn line at some inconvenient point, he should continue by leading into the inked line in the direction in which it is moving, touching the pen to the line very lightly and carefully at a point just before the break in the line (Fig. 20). This must be a swinging motion, or the point of junction will be too obvious. A second method of continuing a line which has been broken is to begin the new part without touching the old line and then to fill in the gap with a finer pen (Fig. 21) after waiting for the previously inked lines to dry.

The work should proceed gradually over the whole drawing, not in strips or areas, that is, detail and shading should be done in a layer-by-layer fashion rather piece by piece like a jigsaw puzzle. Attempting to finish one area at a time

FIG. 19.—Examples of drawing the same subject (leaf of Emory oak, *Quercus emoryi*) with and without outlines. No reduction from the original pen drawing.

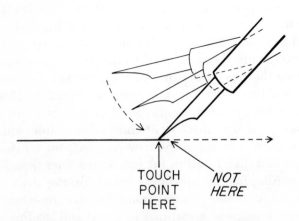

TOUCH POINT HERE

NOT HERE

FIG. 20.—Method of continuing a broken inked line

is likely to introduce errors in shading and emphasis. The completed area may be quite dark, and, in an effort to adjust the rest of the work to this area, the artist may make the whole picture too dark. It is wiser to keep the drawing lighter in tone and to space the shading lines or dots a little more

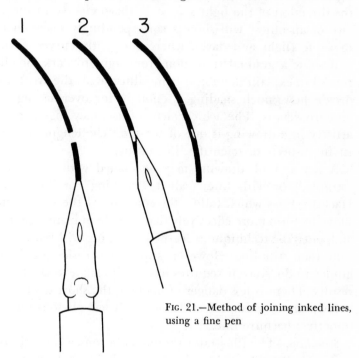

Fig. 21.—Method of joining inked lines, using a fine pen

widely than the artist thinks he desires, because the reduction and engraving process tend to thicken the lines and "close up" the drawing, therefore darkening the picture in general. By viewing the work through a reducing lens from time to time, the illustrator will be able to judge the amount of shading and detail he should use.

Every drawing, even a simple outline, should show the direction of the source of illumination. This may be indi-

cated in an outline drawing by making the line on the shadowed side of the figure heavier than on the lighted side. More elaborate drawings are shaded more completely, as is discussed under the different techniques. The amount of light a surface receives depends on its angle in relation to the direction of the light source. A sharp change in the surface of an object will show a correspondingly sharp change in value (light and dark), whereas a gently curved surface will show a gradual transition from light to dark. Shading is used to explain the object being illustrated; the artist must decide how much shading is enough, for overshading may obscure details. The achievement of accuracy together with artistry in a drawing is one of the most challenging and satisfying aspects of scientific illustrating.

A pen-and-ink drawing may be shaded with dots (called "stipple") or with lines (called "hatching" or "hachure"). Hachure lines which follow the contours of the subject may show the form more effectively than stipple in many instances, and, once the technique is learned, hatching will require less time than stippling. However, stippling is easier for the beginner to do, since it requires less care to achieve satisfactory results. There is less danger of hooking the short strokes (see below), and one imperfect dot is much less obvious than an imperfect hachure line.

Stippling.—The illustrator should use a somewhat rigid pen point. He should employ a light touch, holding the pen vertical and not lifting it more than 2 or 3 millimeters from the surface of the paper. The size of the dots is determined by the size of the pen, not by the amount of pressure used. Pressing the pen harder to produce large stipple dots will result in spattering the paper with ink. When shading from light to dark, the artist should simply space the dots more closely, not use bigger dots. A rough texture may be suggested by stippling which is uneven in both spacing and size of dots. By

using a Leroy socket-holder and points of various sizes, the artist will be able to stipple evenly with a wide range of dot sizes. The stipple dots should not touch one another, except where this is unavoidable in very darkly shaded areas. Stippling is done at random unless a pattern is desired for a special effect. It is worth emphasizing that each individual stipple dot should be placed with care for its size, symmetry, and spatial relationship to other dots. A careless, "rapid-pecking" approach to stippling produces results of poor quality.

Common faults of stippled drawings are dots so fine that they are lost in reproduction and stipple so close that in shadowed areas solid black or irregular fusion of dots results in reproduction. Shading deeper than close stippling allows is effectively obtained by stippling closely and then joining individual stipple marks with a fine pen. The result should look like white stipples on a dark background and can be graded into conventional stippling where a gradual change of tone is needed.

Hatching.—Stippling by hand, if done carefully, may be extremely time-consuming. It is worth the trouble to learn to use hachures for the added speed and convenience over stippling. In many instances a few well-placed hachure lines will show the contours of the subject satisfactorily, whereas it would require several thousand stipple dots to give the same effect. In another circumstance it may be desirable to use both hachure and stipple in the same drawing in order to distinguish structures—skin from fur, for instance, or cartilage from bone.

Hatching lines should run with the contours of the subject whenever possible (Fig. 22). The illustrator should use a flexible point so that he may vary the pressure while drawing and thus vary the line from fine to broad. The strokes should never end with "hooks"; these are avoided when the hatching is done with care, picking up the pen at the end of the stroke

and then moving into the next stroke. It is advisable to plan each line lightly in pencil on the final drawing paper and to follow these guide lines exactly with the pen. In some instances the artist may not wish to vary the width of his hatching, in which case he must increase the number of hachure lines in order to give the impression of shadow, or he may use crosshatching. Well done, crosshatching can be very effective

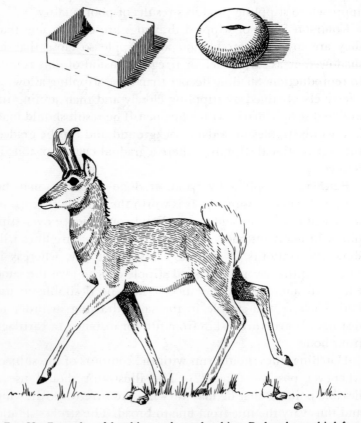

Fig. 22.—Examples of hatching and crosshatching. Reduced one-third from the pen drawing on plate-finish paper. Subject is the pronghorn, *Antilocapra americana*.

and labor-saving; done carelessly, it may ruin the drawing. One difficulty with crosshatching is that it is more likely to "close up" and blot in the reproduction than will plain hatching of equal quality.

As it is assumed that the work of the biological illustrator is intended for publication, the directions and suggestions given here are pointed toward that end. Often the engraver hears the illustrator say that it is all right if particular fine lines or fine stipple dots "fall out" during reproduction because "they are really not essential anyway." The artist has drawn each line and dot to give a certain impression to the viewer. If the absence of such lines or dots would not alter that impression, he should not have drawn them in the first place. The camera cannot choose what to keep and what to drop out and will tend to retain only parts of too-fine areas, creating an impression somewhat different from that which the illustrator intended. If it is desirable for all the lines and dots to be reproduced, the artist must draw them firmly, which does not mean coarsely. If he is in doubt about a line, he should strengthen it or eliminate it.

Special grounds.—By using special grounds, the illustrator may produce a satisfactory picture in a fraction of the time it would require to stipple the same area by hand. Coquille board is a paper ground which has a textured surface resembling finely wrinkled paint or silk crepe material with tiny ridges and depressions. It is available in several degrees of roughness. The outline is drawn with very faint pencil strokes or with ink, and shading is done with a medium lithographic pencil or a black china marking crayon. Rubbing the surface of the Coquille board lightly with the lithographic pencil will produce a fine random stipple effect, and harder rubbing will produce a darker stippling effect (Fig. 23).

The finished work is reproduced by zinc cut or, if very fine, by copper cut. The illustrator generally should use a some-

what coarse-textured Coquille board and keep the work "open," because the finest grades may not reproduce well.

Ross stipple board, used in the same manner as Coquille board, is available in several degrees of fineness and in various patterns (Fig. 24). An advantage of Ross board is that areas may be scratched out with a knife or scratchboard tool, increasing the illustrative possibilities (see Fig. 12). Ross board is quite fragile and should be firmly mounted on a stiff back-

Fig. 23.—Examples of Coquille board

Fig. 24.—Examples of Ross stipple board. (Courtesy Chas. J. Ross Co.)

ing before it is used. The drawing is reproducible as a line cut.

These special grounds are indeed time- and labor-saving, but they are also more expensive than the materials for simple pen-and-ink drawings. Ross board averages in cost about five times that of good drawing paper, and Coquille board is about one-half the cost of Ross board.

Dry brush.—This is a technique less commonly used by the biological illustrator. By using a brush holding only a small amount of ink on a rough-textured paper, the artist can make an illustration which may be reproduced by line cut (Fig. 25). Watercolor paper, which may be obtained in a great variety of textures, is well suited for the dry-brush technique. The rough surface will catch the ink on the raised parts while leaving depressions white. This technique generally is not adapted to exactly detailed renderings but may be used to advantage to illustrate fur, tree bark, or some landscapes.

Scratchboard.—Scratchboard is a thin cardboard coated on one side with fine chalk. Ink is painted or drawn on the chalk surface, and, by scratching the ink with a sharp tool, the artist exposes the white ground.

There are several brands of scratchboard. In general, the least expensive brand is too soft and the chalk layer is too thin. One of the more expensive imported brands is hard and thick but too gritty. Even the best domestic brand is not always uniform in quality. Before buying, the illustrator should examine each sheet of scratchboard for imperfections such as tiny cracks which will hold the ink too deeply to be removed.

Scratchboard should be trimmed to drawing size with a razor blade, for using scissors will cause cracks to develop along the cut edge. The artist should allow a good margin, at least $1\frac{1}{2}$ inches, from the edge of his drawing to the edge of the scratchboard and should mount the scratchboard on a

Fig. 25.—Examples of dry-brush technique. The three samples above the landscape were done on (*left to right*) plate-finish paper, bond paper, and watercolor paper. The landscape was done on heavy bond. The lines in the sky were brushed in as lightly as possible; after the picture was completely dry, these lines were lightened still further by vigorous erasure.

slightly larger piece of poster board before beginning to draw. A scratchboard tool that fits into a penholder is available at art-supply stores, but this author finds an X-acto knife with No. 11 blades most convenient to use.

The usual method of drawing on scratchboard is to make a pencil outline of the subject and, with brush and ink, fill in the whole penciled area, or all areas except those which are to be left completely white. After this silhouette is allowed to dry thoroughly, scratching is begun. If the illustrator attempts to scratch while the ink is still damp, the chalk will crumble away like cheese. Placing the drawing on a warm radiator or beneath a light bulb for a few minutes will dry the ink. In humid weather the scratchboard may have to be dried every few minutes. Blowing on the surface to remove dust also will dampen the scratchboard. Rather than actually scratching the board, the artist should employ a light scraping motion which will remove ink with a minimum of gouging and routing of the chalk surface. If scraping is done gently, the area may be re-inked and rescratched if necessary. Too much reworking will eventually remove the chalk down to the cardboard backing.

It is important to protect scratchboard, or any drawing surface, from being smudged with oil from the fingers and hands. Even the slightest trace of oil on the ground will cause subsequently drawn lines to "fuzz." Keeping a clean slip of white paper under the hand usually is sufficient protection for the ground.

The lines are carefully planned on the silhouette with the point of the scratch knife. The illustrator very gently scrapes thin lines the width and length he desires. Figure 26 demonstrates successive steps in scratchboard technique, from placing the lines to completing the shading. Usually, finer lines are used to suggest distance, whereas wider white and black lines are used in the nearest parts of the subject. In a given

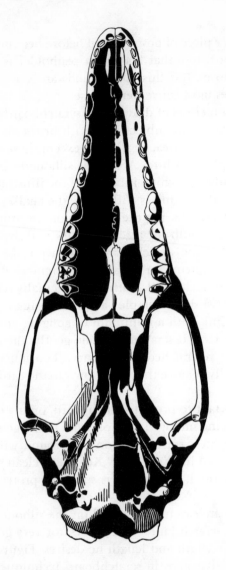

Fig. 26.—Steps in making a scratchboard drawing. Reduced about three-eighths from a drawing of the ventral view of the skull of a bandicoot, *Peroryctes broadbenti*. *A,* The outline is made, and all shadowed areas are painted black. (Some hatching may be drawn with a pen to be scratched later.)

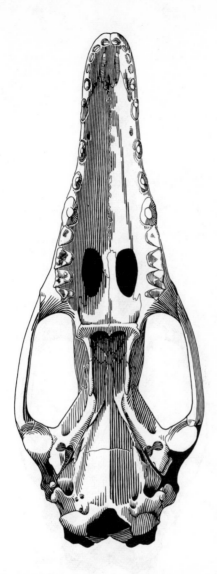

Fig. 26, *Continued.—B,* The hatching (*contour lines*) is carefully planned with the fine X-acto knife or scratchboard tool. Distant parts are separated from the foreground parts of the drawing by breaking the lines at points of junction. The sutures are drawn through the hachure lines. The modeling of the contour lines proceeds gradually.

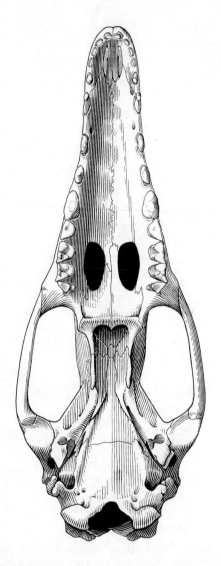

F<small>IG</small>. 26, *Continued.—C*, The suture lines are brought into prominence by breaking the hachures in contact. The shadows are adjusted by carving each contour line.

area the black lines are thin and far apart in the light region and become closer and thicker as the shadow increases.

The artist may prefer to draw each line in ink on the scratchboard rather than scrape white lines through a solid black area. This method is used when making an outline drawing on scratchboard. Either a pen or a fine brush may be used to draw. The pen will produce a dense black line but may scrape the chalk surface, becoming gummy or causing gouges in the ground. The brush, therefore, is preferred for drawing lines on scratchboard, but the artist must be sure to draw the lines densely black, not allowing the ink to thin to gray.

One of the common mistakes when using scratchboard is scraping the lines too fine to reproduce well. Very thin black lines may not be reproduced at all, and dark areas with very thin white lines may "close up" and become completely black. In general, fine broken lines are unsafe to use, since they are lost in reproduction more often than not.

The advantages of scratchboard over pen-and-ink drawings on ordinary drawing board are several: long, smooth lines may be done with ease; an unsatisfactory line may be re-drawn; the shading may be adjusted as the drawing proceeds and may even be changed if desired; mistakes and ink blots are simply scraped away. Subtle shading and use of contour lines are possible with scratchboard, but this technique is very time-consuming.

Scratchboard is more expensive than ordinary drawing board, costing some three to four times as much. A most satis-factory substitute is acetate or polyethylene film, manufac-tured by several companies. This ground may be rolled, is sufficiently transparent that the finest details may be traced, may be scratched and rescratched, and is inexpensive. The illustrator draws with brush or pen on the frosted side of the film, using a white ground behind it. The completed drawing

should be taped to a stiff white back. Medium-weight, easily rolled acetate or polyethylene sheets have been found the most convenient to use and most suitable to the scratch technique. It is sold by the yard or roll at most art-supply stores. Acetate film should not be placed on a radiator or under a warm lamp; the ink must dry unassisted. Since ink cannot be applied to oily film, the illustrator must protect the surface from contact with his fingers. The view from the non-frosted side of the film will show a sharper picture (in mirror image), but either side will reproduce well. If necessary, a drawing on either of these films may be washed off with soap and water, and the clean film may be re-inked.

Charcoal drawings.—Charcoal is bought in slender sticks of varying degrees of hardness. The ground is a paper which is especially surfaced to hold the charcoal dust. The artist draws with the stick of charcoal much as if he were holding a pencil. Charcoal may be smudged on the paper with the finger or with a chamois. A drawing done without smudging may be reproduced as a line cut if it is not done on too fine a paper, but a drawing smudged and shaded into grays must be reproduced by halftone, offset, or collotype. Charcoal may be erased with a kneaded eraser if the dust has not been ground into the paper too deeply. The sticks of charcoal may be kept pointed by rubbing them on a piece of sandpaper. The drawing should be done on a fairly large scale in order to include detail. Precise drawing with charcoal is not so easy as with pen or pencil, and reduction is used to smooth lines and edges. Satisfactory scientific illustrations have been executed in charcoal, the drawing having been reduced and then reproduced with a fine halftone screen.

Toned Illustrations

Toned illustrations are drawings or paintings in which the values are represented in color or in varying shades of gray

from light to black. Such illustrations are reproduced by half-tone, offset, or collotype.

Pencil drawings.—The artist will need pencils of hardness range including 3B, HB, 2H, 4H, and 6H. The ground must be of good quality. Kid-finish illustration board, plate-finish drawing paper, and Bristol board are recommended. A piece of fine sandpaper will be of aid in keeping sharp points on the pencils. Other items of equipment include a kneaded eraser, paper to place under the drawing hand to prevent smudging accidentally, and a rolled-paper smudger. This last tool may be obtained at art-supply stores or can be made by rolling a strip of paper tightly with one end protruding in a point (Fig. 27). The artist may use his finger to smudge, but this

Fɪɢ. 27.—Rolled-paper smudger

will mix a bit of oil with the graphite, making erasure difficult.

Plate-finish drawing paper is used when very precise, tiny detail is required. As the slick surface does not hold graphite as well as a rougher surface, harder pencils are used with this ground. The preliminary lines are drawn lightly with a hard, sharp-pointed pencil. Softer leads are used to draw in the shadows, the softest lead producing the darkest and widest lines. Shadows may be hatched, softer leads giving darker results, or the hatching may be smudged for a softer or more gradual shading effect. The illustrator should take care to note that, because hard leads do not smudge easily, a line drawn even moderately heavily will remain as an obvious line. Pure-white areas within the margins of the subject should be avoided, for these areas must be tooled out, adding to the cost of reproduction.

Very soft effects can be obtained by using a kid-finish paper and softer pencils. The outline is again drawn lightly in hard pencil and the shading done with softer leads.

Pencil drawings have a soft and pleasing quality and may be executed with ease and speed, but there are disadvantages. The work must be protected from smudging while drawing and afterward, and erasures, unless done perfectly, will show in reproduction. The cost of reproduction is greater than for

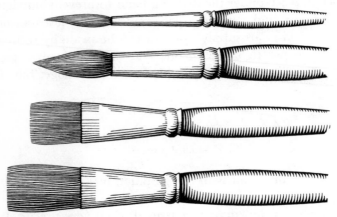

Fig. 28.—Examples of flat and round brushes. Reduced one-third from the original scratchboard drawing.

black-and-white illustrations. The finished drawing should be sprayed with a fixative or protected by glass. Charcoal fixative is suitable and may be purchased at art-supply stores. Clear plastic spray may be even better, since it has less tendency to darken the drawing.

Wash drawings.—Liquid India ink, a dry block of ink, Chinese ink, or a pan or tube of good-quality black watercolor is used in making a wash drawing. Several watercolor brushes, both flat and round (Fig. 28), are necessary. The wide flat brush is used to apply the broad areas of wash, and the round brushes are used for details and should be available in

medium and small sizes. A wash drawing may be done on watercolor paper, which must be prepared beforehand, or on stiff illustration board.

If he is using watercolor paper for a wash drawing, the illustrator will need a wooden board or a piece of Upson board and a roll of strong, gummed-paper tape. The subject is drawn very lightly in hard pencil on the dry paper. The pencil drawing must be done as lightly as possible, or lines will show in the final product. The paper must be damp in order to apply a wash properly. There are two usual methods of preparing the paper. In one, the paper is fixed firmly to the board with gummed-paper tape all around the edges and then is wet with a wide brush and clear water. The paper is allowed to shrink flat before proceeding with the wash. In the second method, the paper is soaked in clear water for a half-hour or more and then is removed and securely taped to the board. If desired, the wet paper may be pressed between slightly damp blotters before being taped down. The second method of preparing the paper is recommended, in general, for better results. The paper must not be shiny with excess water or have puddles of water on its surface. Blotting or gentle wiping with a dry brush may be used to remove excess moisture.

Illustration board cannot be soaked, of course. The surface is dampened by brushing with clear water and a wide brush.

The pigment is mixed with clear water to the desired shade, the lightest wash being applied first. The entire picture should be covered with at least a light wash to eliminate pure-white areas that would need to be tooled out in the engraving.

A flat wash is applied in the following manner. The paper on a drawing board is tilted slightly toward the illustrator. Enough color is mixed to cover the entire area to be washed. Using a wide, flat brush full of color but not dripping, the illustrator quickly and lightly paints a strip across the top of the wash area. Subsequent strokes must overlap preceding

strokes slightly so that no dark streaks will be apparent. The last stroke may be applied with a less wet brush, and the tiny puddle of surplus color at the bottom of the last stroke may be absorbed with the squeezed-out brush. If done properly, the whole area should be covered by an even layer of pigment.

The wash when first applied should appear slightly darker than desired, for it will dry lighter. The paper should be less damp to receive the darker washes and quite dry for small dark areas. A lighter-toned picture generally is more pleasing than a darker one, but the range of values should be sufficient to represent the subject well and to make the drawing interesting. Areas to be left white may be covered with rubber cement before applying a wash. The cement can be rubbed off later and ink lines added. (Figure 3 [p. 9] is an example of a wash drawing.)

Stippling and line work done with pen or brush must be added after the paper has dried. The illustrator must remember that solid lines will appear broken in a wide-screen halftone reproduction and should avoid them unless a fine halftone screen, offset, or collotype is to be used.

Wash drawings may be better than any other technique for rendering qualities such as softness and fur and certain light-and-shadow effects. Once the wash technique is mastered, the drawing may be done quickly. Mastery of this medium, however, requires time and practice; it is no easy matter to apply a finely graded wash or to apply tones without blurring the edges. The excellent results are well worth the effort.

Transparent watercolor drawings.—The artist should use good-quality pan or tube watercolors and good round and flat brushes. Cheaper materials are a poor investment; the pigments may fade or be gritty, and poor brushes will fray and lose hairs. The ground for a watercolor is prepared as for a wash drawing (see above). The pigments should be applied lightly and rapidly to prevent the paper from drying too

quickly. In general, the lightest areas are done first, the darkest colors and sharpest details being done last.

Areas to be left white may be covered with rubber cement before the painting is begun. Interesting effects have been achieved by scratching the dry painting with a sharp instrument to make a white line. Experimentation is encouraged.

One is not limited to the customary "free" style usually associated with watercolors. Very successful tight, detailed renderings have been executed using this medium. For such paintings the ground should be only slightly damp, and the colors are painted over one another as in oil painting. Much care should be exercised, since overpainting can so easily get out of hand, resulting in an obvious blotch or a generally muddy appearance. In watercolors, as in any form of color work, the less mixing of pigments the better.

Gouache drawings.—By "gouache" is meant a quick-drying, opaque watercolor. The paint quality of gouache is between transparent watercolor and oil paint. It is fairly easy to handle and may be "worked over" to a small extent, but this must be done carefully.

The ground used for gouache paintings should be stiff enough to resist warping. Illustration board and gesso panel have good surfaces and sufficient absorbency for the use of gouache. Good-quality sable brushes, flat, round, and bright, are necessary. The paint itself may be had in jars or tubes and may be called also "poster paint," "artist's opaque," "designer's opaque," or "showcard color."

Gouache may be used thick, from the tube or jar, or it may be thinned with water and applied as a wash. It will not dry as quickly as transparent watercolor and so may be moved with some flexibility on the board. Gouache is easier for the beginner to use than transparent watercolor and has been successfully employed in biological illustration.

Casein paintings.—Casein paint has the flexibility and ease of oil paint but is used with water, like watercolors. It may be thinned and washed on the drawing, or it may be applied thickly with oil-painting brushes. Casein paint may be "worked over," but it dries more rapidly than oil paint. The ground should be stiff. Gesso panel, cardboard "canvas," and true oil canvas are all suitable.

Oil paintings.—Oil paints are easier for the beginner to use than watercolors. They are mixed with turpentine and linseed oil to the desired consistency. If linseed oil is not used, the paint will crack and flake from the canvas when dry. It is well to mix as few different colors as possible to obtain a desired color, for, the more mixing, the muddier will be the resulting color. Oil paint is applied to stretched canvas, cardboard "canvas boards," gesso panel, or wood. The brushes are cleaned first in turpentine, and then in cool water and pure soap.

Methods of Correcting Mistakes

Several methods of erasing or eradicating errors in ink are available. Scraping the ink with a sharp knife or razor may remove it, but, unless done with extreme care, it will remove the paper as well. A fiberglass eraser will do the same. By rubbing a piece of pumice (soapstone) over the roughened area of the erasure, the illustrator can smooth the surface sufficiently to redraw the erased line. Erasure sometimes is not advisable or necessary, as in the event of large blots of ink or accidental lines which do not mar the lines of the drawing or which appear in areas without drawing. This type of error should be painted over with super-white gouache or covered with a small strip of white paper. Such covered-over areas will not be apparent in line-cut reproductions. Super-white gouache and pasted strips of paper also may be used advan-

tageously to thin lines in the drawing and to straighten blotted or blurred edges of ruled ink lines.

Pencil lines should be removed from the finished ink drawing in a way that will not lighten or smear the ink. A kneaded (charcoal) eraser is the safest kind to use. Wiping the drawing very gently with a clean cloth moistened with carbon tetrachloride will safely remove pencil marks and finger smudges, provided the pressure is not so great as to remove the ink lines as well.

Errors and smudges on pencil drawings should be erased very carefully with a kneaded eraser. Errors in wash drawings cannot be satisfactorily erased, but smudges should be erased or painted out cautiously. Errors on gouache, casein, and oil paintings may be painted over. The illustrator should not use pasted strips of paper to cover errors on toned drawings, since the edges of the cover strip will be apparent in the reproduction unless tooled out of the plate at extra cost.

Selected References

BERRY, WILLIAM D. and ELIZABETH. *Mammals of the San Francisco Bay Region*. Berkeley: University of California Press, 1959.

CLARKE, CARL DAME. *Illustration: Its Techniques and Application to the Sciences*. Baltimore: John D. Lucas Co., 1940.

COLBERT, EDWIN H., and TARKA, CHESTER. "Illustration of Fossil Vertebrates," *Medical and Biological Illustration* (London), X, No. 4 (1960), 237–46.

GUPTILL, ARTHUR L. *Drawing with Pen and Ink*. New York: Reinhold Publishing Corp., 1961.

HIGGINS INK CO., INC. *Techniques*. Brooklyn: Higgins Ink Co., Inc., 1959.

KAUTZKY, TED. *Ways with Watercolor*. New York: Reinhold Publishing Corp., 1949.

MAYER, RALPH. *The Artist's Handbook of Materials and Techniques*. New York: Viking Press, 1940.

NICOLAIDES, KIMON. *The Natural Way To Draw*. Boston: Houghton Mifflin Co., 1941.

PITZ, HENRY CLARENCE. *Pen, Brush and Ink*. New York: Watson-Guptill Publications, 1949.

RIDGWAY, JOHN LIVESY. *Scientific Illustration*. Stanford, Calif.: Stanford University Press, 1938.

STEBBINS, ROBERT C. *Amphibians and Reptiles of Western North America*. New York: McGraw-Hill Book Co., 1954.

5 PREPARATION OF GRAPHS AND MAPS

One of the most important functions of the scientific illustrator is the preparation of graphs and maps. A properly prepared illustration of this type can convey a wealth of information quickly and accurately, and often more effectively than is possible in the accompanying text. Some cautions should be mentioned at the outset. Unless the artist is expert at freehand lettering, all lettering should be done with the aid of a stencil or, preferably, a lettering device. Uneven, freehand lettering detracts greatly from the professional look desired in the finished illustration. Particular attention should be paid the matter of reduction of the drawing in publication. Many an otherwise good graph or map has been made virtually useless by reduction to a size that rendered important features illegible. The illustrator must be certain that letters and symbols are large enough in the original drawing; he should not assume that the editor will specify reduction appropriate to the size of letters and symbols. Also, the illustrator must guard against trying to present too much information in a single figure, lest the basic advantage of a graph or map—presentation of a clear, coherent picture of data—be lost.

Materials and Special Techniques

The use of materials and instruments especially suited to the construction of graphic illustrations is considered here.

Grounds.—Graph paper may be purchased which is ruled in the metric system or in inches and fractions thereof. The lines

may be one of a variety of colors: red, brown, green, black, blue, or violet. The choice of color will be determined by whether it is desired to have the complete grid system appear in the published figure. As pale blue will not reproduce photographically on the emulsion used in preparing line cuts, a figure may be drawn directly on graph paper of that color and submitted in this form for publication. The reproduction would show no trace of the pale-blue grid system of the original ground. It is a good practice to mount an illustration done on such lightweight paper on stiff board.

If the final work is to be done on an unlined ground, the artist will find Bristol board, illustration board, and good-quality white poster board suitable. He should not attempt to erase an inked rendering on poster board, because even light erasure tends to lighten the inked lines considerably.

In many instances an illustration may be planned on graph paper and then transferred to the plain ground by the carbon method or by pouncing, as is explained on page 84. In the preparation of maps it is often convenient to use a transparent tracing ground such as vellum, tracing linen, or a polyethylene or acetate drafting film. The films come in sheets and rolls and may be washed and reused. Polyethylene film is more durable than acetate film. An appropriate base map may be traced on one of these grounds, and only the pertinent details included.

Railroad pencil or pen.—The instruments are used to draw two parallel straight or curved lines (Fig. 29). A usage of particular value in mapmaking is laying out curved lines to guide lettering that follows a curve, for example, the name of a river.

Pens.—The illustrator may wish to use a ruling pen for drawing lines (Fig. 30), but the Leroy socket-holder with different sizes of points (Fig. 31) is a more convenient instrument to use and is less likely to cause blots at the beginning or end of

a ruled line. The Leroy pen is equally well adapted for use with a rule (curved or straight), a template, or freehand. This pen produces a line of even width preselected in the choice of point. If a line of variable width is desired, a conventional pen point, responsive to varying pressure, is used. It is some-

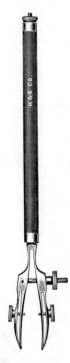

FIG. 29.—Railroad pen. (Courtesy Keuffel & Esser Co.)

times necessary to darken a line that has previously been drawn. Such a line, when thoroughly dry, may be gone over with a fine mapping point.

Ink.—Absolutely black, waterproof drawing ink should be used; a free-flowing, non-gummy brand should be employed in the Leroy socket-holder pen. A special non-wrinkling ink

Fig. 30.—Ruling pen. (Courtesy Keuffel & Esser Co.)

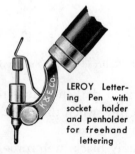

LEROY Letter-
ing Pen with
socket holder
and penholder
for freehand
lettering

Fig. 31.—Leroy socket-holder and socket in penholder. (Courtesy Keuffel & Esser Co.)

is available for covering solid areas without causing warping of lightweight grounds.

Rules.—The illustrator will find an 18- or 24-inch metal rule to be of great value. A metal rule generally is a more true straightedge than a wooden rule, and the greater length will aid in ruling long lines. A wooden rule with a metal edge is also good but should be checked for straightness. Plastic rules may be suitably straight but often warp in time. A clear plas-

Fig. 32.—French curves. (Courtesy Keuffel & Esser Co.)

Fig. 33.—Flexible curved rule. (Courtesy Keuffel & Esser Co.)

tic rule scored in a $\frac{1}{8}$-inch grid is a most valuable tool in making preliminary pencil drawings, especially where right angles and parallel lines are drawn. Unfortunately, this type of rule is most difficult to use with ink without smearing and blotting.

A T-square, used in conjunction with a drawing board with two truly perpendicular edges, will facilitate the ruling of parallel and perpendicular lines.

Curved lines may be ruled with the aid of a set of ship's or French curves (Fig. 32). Flexible curved rules (Fig. 33) may

be purchased but are not usable where a curve of relatively short radius is needed. The artist may easily construct his own curved rule by the following method: The desired curve is drawn freehand on a sheet of thin paper such as tracing paper. This is pasted to a piece of mounting board (poster board), and the curve is cut out with scissors or a razor blade. The curved edge should be rubbed very smooth with fine sandpaper. This cardboard curve is then elevated from the drawing surface by the method given on page 80 (Fig. 38).

Ruling parallel lines.—It is sometimes desired to produce parallel lines, as, for example, in placing grid co-ordinates or, borders on a graph or map. Three methods described here will serve in most situations that arise.

Where a T-square and drawing board are available, a line may be drawn along one edge of the paper, and the intervals between the desired parallels marked along this base line. The T-square is placed with the short bar parallel to the base line, and the parallels are ruled along the long arm of the T-square at the indicated points. A drafting triangle may be used in the same manner, with the base held parallel along the base line.

A line may be drawn parallel to a given line by using a compass. At any two points along the first line the compass point is fixed, and two arcs are drawn on a radius equal to the desired separation of the parallel lines. The second line is drawn tangent to the arcs (Fig. 34).

At times the illustrator may wish to rule evenly spaced parallel lines without the bother of measuring out odd fractions. The desired rectangular space is delineated, as rectangle *ABCD* in Figure 35. In the example this rectangle is to be divided into eleven equal parts. Lines *AB* and *CD* are extended as *EAB* and *DCF*. After finding eleven convenient divisions such as 11 inches on a rule, this distance is laid off diagonally between lines *EAB* and *DCF,* and the eleven divi-

sions marked along the diagonal, *EF*. If side *AD* is parallel to the edge of the drawing board, lines parallel to *DC* and *AB* may be drawn through the marked points with a T-square.

Another method utilizes diagonal lines but does not require a T-square. For example, a rectangle, *ABCD* (Fig. 36), is

Fig. 34.—Drawing parallel lines by using a compass

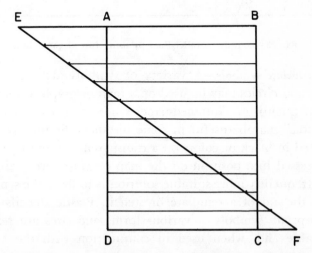

Fig. 35.—Drawing parallel lines by using a T-square and a diagonal line

to be divided into seven equal parts. Seven convenient divisions are found on a rule, and this distance (line *ab*) is located between *EF* and *GH*. Another line (*cd*) equal in length to line *ab*, also located between *EF* and *GH,* will be parallel to *ab*. When the divisions previously located on the diagonals are connected, the connecting lines will be parallel.

Fig. 36.—Drawing parallel lines by using two diagonal lines

Producing symbols.—A variety of symbols such as crosses, stars, and circles may be used on a map or graph to plot different quantities. Gummed-paper symbols such as "map signal dots" may be useful in some instances. Similar symbols printed in black or colors on a transparent ground that may be pressed into position on the map or graph are available.

A frequently more suitable solution is to draw the symbols with the aid of a template or stencil. Plastic stencils with appropriate symbols of various forms and sizes are readily available and, when used in conjunction with the Leroy

socket-holder and pen, allow the illustrator to draw neat and uniform symbols.

A standard lettering set will include on its templates some figures such as circles and crosses useful as symbols. For use with the more expensive lettering sets, it is possible to obtain templates devoted solely to a diversity of symbols.

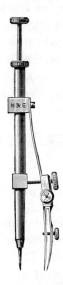

Fig. 37.—Drop-compass. (Courtesy Keuffel & Esser Co.)

Where symbols based on a circular form are desired, these may be drawn in a wide range of sizes with the aid of a drop-compass (Fig. 37).

In general, it is best not to have two symbols in contact on a map or graph. Where two points to be plotted fall so close together that there is not room for two complete symbols, one may be drawn overlapping the other. A clear space should separate the superior (complete) symbol from the inferior. This will help to prevent the symbols from running together

and becoming illegible when reproduced. Similarly, symbols should dominate over lines and other markings on illustrations; that is, where a symbol and line come into conflict, the line should be broken to allow the symbol to stand clear.

Use of rules and templates.—A straightedge, curved rule, or template to be used with a pen must be raised from the drawing surface to prevent the ink from being smeared. If the rule is not constructed in this fashion, a riser made of a strip of blotting paper or thin poster board may be affixed to the underside with rubber cement, as is shown in Figure 38. This riser should be set back $\frac{1}{8}$–$\frac{3}{16}$ inch from the ruling edge. In the case of a template, several narrow strips of poster board arranged so as to avoid the holes but provide a firm footing

FIG. 38.—End view of a rule raised from the surface of the drawing paper

may be used. The illustrator should remember not to slide the rule away from the wet line but to lift it free of the paper when changing its position. The safest procedure is to leave the rule in place until the inked line is completely dry. Also, care must be taken not to draw a second line to or from one which is still wet. Not only is there the likelihood of smearing with the rule but a blot may be produced at the point of junction of the two lines.

Shading patterns.—There are several ways in which an illustrator may produce a pattern over the whole or part of a graph or map. The least satisfactory method is by pen and ink, making a pattern of stipples, hachures, or other marks. The result is most often an uneven, amateurish-looking job.

Singletone and doubletone Craftint are special grounds upon which an illustrator draws his figure in the conventional

fashion with waterproof black drawing ink. One or two invisible patterns contained on the paper are developed and made visible by the application of a liquid developer to the part of the drawing in which shading is desired. By using singletone sheets, three degrees of shading may be obtained:

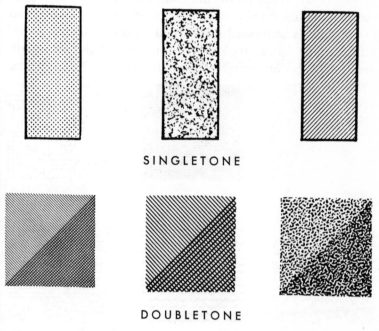

SINGLETONE

DOUBLETONE

Fig. 39.—Examples of Craftint shading mediums. (Courtesy Craftint Manufacturing Co.)

white, pattern, and black. Doubletone provides four alternatives. The illustrator must take care to buy only fresh material, or the pattern may not develop dark enough to reproduce satisfactorily (Fig. 39).

Transparent overlay shading films are in wide use and are available in a multitude of patterns printed in black, white, and colors (Fig. 40). There are two general classes of these

films. In one, the printing is on the lower (adhesive) surface; in the other, on the upper surface. These will be discussed in order.

In using film with printing on the adhesive surface, a piece of film large enough to overlap the area to be shaded is pressed down firmly on the drawing. The desired area is then outlined with a sharp needle or razor blade. The area within the outline is burnished down hard with a smooth wooden burnisher or similar tool or with the back of the fingernail, and the surplus film outside the outline peeled off. If lettering

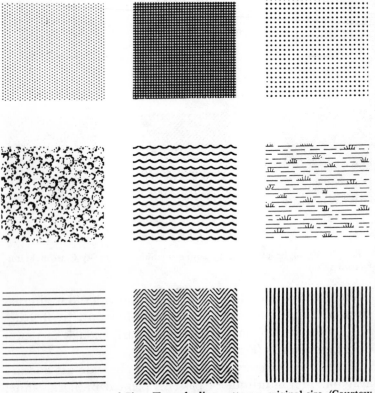

Fig. 40*A*.—Examples of Zip-a-Tone shading patterns: original size. (Courtesy Para-Tone, Inc.)

or symbols appear in the shaded area, the superimposed pattern should be removed by outlining and peeling before the final burnishing affixes the film too tightly to the ground. The lettering should appear in a clear, unpatterned space. Another method is to do the lettering on plain, white paper, cut it out, and paste it in place over the film. If it is found necessary to eliminate pattern after the film has been burnished, this may be done by painting over with super-white gouache. Shading films, such as Zip-a-Tone, may be purchased which are backed

Fig. 40*B*.—The same patterns as in Figure 40*A*, reduced one-half. (Courtesy Para-Tone, Inc.)

with a wax adhesive or with a heat-resistant adhesive. Glossy and mat finishes are available.

Film with the printing on the upper surface must be handled in a slightly different fashion. The processes of applying and cutting the film are similar, but permanent attachment of the film to the ground is achieved by resting a weight on the drawing rather than by hand burnishing. Since the printed pattern is easily removed by abrasion, extreme care in handling is necessary. A touch from a tool or even a carelessly dragged fingernail can result in a disfiguring scratch on the pattern. Though it is at times useful to be able to remove pattern at will, the hazards attendant upon working with this type of film render it less useful. When a figure is completed in this film, it must be sprayed with a plastic fixative to prevent damage in handling.

Where two or more patterns are used in a single figure, the artist should try to separate patterns which are similar in value. For instance, it is unwise to place side by side a dot pattern and a line pattern of similar degrees of grayness. They should be separated by a darker or lighter pattern for the sake of clarity (see Fig. 48).

Transferring.—In the previous chapter, the carbon and the tracing-table methods of transferring a sketch to the final ground have been described (see p. 45). Both methods may be used effectively in the preparation of graphs and maps. A third method—pouncing—is especially applicable to graphs because of the many straight lines and angles involved. The rough graph is placed over the final ground on the drawing board, and both are firmly fixed in place with drafting tape. With a sharp pin, junctions of lines, points on scatter diagrams, and similar important points of reference are pierced lightly so that the pin marks on the final ground. Care must be taken so that a hole large enough to catch the pen point is not made. With the pinpricks as guides and the

original rough draft as a reference, the final graph may be drawn.

Graphs

The purpose of a graph is to present a comprehensive and lucid picture of data and of relationships between different sets of data. A given set of data can often be presented graphically in a number of different ways. In order that the illustrator may be familiar with several methods of graphing data of various sorts, and may thus choose the most appropriate illustration, the more important kinds of graphic presentation are figured and discussed below.

Scatter diagrams.—In the most common type of scatter diagram, a point is used to represent two quantities the values of which are scaled on rectangular co-ordinates. The horizontal co-ordinate is known as the X-axis, or abscissa, and the vertical as the Y-axis, or ordinate. It is customary that the lowest values be located at the left of the X-axis and at the bottom of the Y-axis. Usually it is necessary only to number the values along the bottom for the X-axis and along the left-hand side for the Y-axis, though clarity may sometimes require that the values be indicated on all sides. The explanatory label along the left-hand Y-axis should be placed so as to read properly when the graph is rotated 90° clockwise.

There is no set rule as to whether grid-co-ordinate lines should appear on the face of a scatter diagram. In many instances a glance at the values scaled on the margins of the graph will be sufficient to allow the reader to estimate the quantities indicated by any particular point on the graph. Where more precision in reading is desired, some basic intervals may be ruled in (see "Ruling Parallel Lines," p. 76). If great precision is called for, it will be best to construct the diagram on graph paper that is printed in black ink which will reproduce in the line-cut process.

A HANDBOOK OF BIOLOGICAL ILLUSTRATION

The example in Figure 41 is a scatter diagram in which head width of several individuals is plotted against length of tibia. Individuals of another category—in this case, the other sex—may be added to the diagram and plotted with a different symbol, as in Figure 45, where female specimens have been graphed along with the males represented in Figure 41. The variety of categories that could be included in a graph is, of course, limited only by the number of symbols that may be devised. In practice, clarity demands that the number be

FIG. 41.—Simple scatter diagram, with several individuals of a single class plotted. (Measurements are of the barking frog, *Eleutherodactylus augusti*.)

limited. Two easily read graphs are to be preferred to one that is overly complicated.

The graph discussed above is based on a system of rectangular grid co-ordinates. It is also possible to construct a scatter diagram on angular and polar co-ordinates in which one value is determined by the direction the radius takes and the

FIG. 42.—A polar scatter diagram. The plots indicate traps at which flies, released at the central point, were recaptured. The number of flies is indicated beside each dot; open circles mean an empty trap. Concentric circles are spaced at 2-mile intervals. (Data are from Bishop and Loake, *Jour. Agric. Res.*, Vol. XXI, No. 10 [1921].)

other is scaled along the radius. An example of this sort of diagram is shown in Figure 42.

Line diagrams.—Where data are graphed as frequency of occurrence on the *Y*-axis of some variate scaled on the *X*-axis, it makes for a clearer presentation if the points are connected

Fig. 43.—A frequency polygon, a form of line diagram. This figure presents raw data (in this instance the snout-vent length measurements of 109 lizards, *Xantusia vigilis*) without grouping or other modification. (See Figs. 44 and 46.)

to form a continuous line. This results in the formation of one or more irregular or regular figures beneath the line, and the graph is hence known as a frequency polygon. Such a diagram is shown in Figure 43. When raw data are used, a very irregular polygon may result. It is proper to group data, which often will produce a smoother polygon. In the example in Figure 44, the data of Figure 43 have been replotted and grouped in intervals of 3 millimeters, although the original data were recorded in intervals of 1 millimeter. Note also that

the *Y*-axis has been changed from an absolute to a relative scale. The choice of absolute or relative (percentage) numbers for the *Y*-axis will depend upon circumstances involving presentation in the accompanying text and comparison with other graphs.

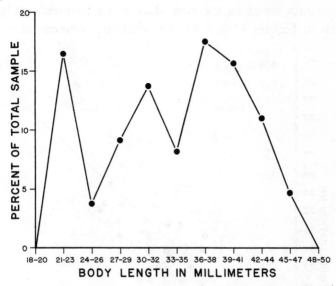

FIG. 44.—A frequency polygon, based on the same data as Figure 43, but with the ordinate changed to reflect numbers as a percentage of total sample rather than as actual numbers and with the abscissa grouped into intervals of 3 millimeters.

Often the data presented in a scatter diagram may be expressed in the form of a line which is estimated by eye or calculated mathematically to average the many point observations. Figure 45 shows lines that by calculation illustrate the average trends for the data presented in scatter form in Figure 41. A good practice is, as was done here, to combine in one graph the individual points of the scatter diagram with the lines representing those points.

Bar diagrams.—Bar diagrams are graphs in which a line or rectangle represents each category.

A histogram is a variety of bar diagram that presents frequency data in a form that is often somewhat more easily comprehended than the frequency polygon. Figure 46 is a histogram based on the same data as the frequency polygon seen in Figures 43 and 44. An additional refinement in the

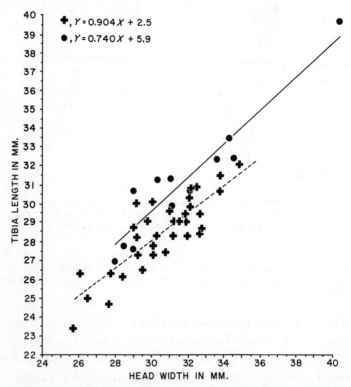

Fig. 45.—Combination of line- and scatter-diagram techniques. A second class has been added to the data of Figure 41, and mathematically calculated lines of best fit emphasize and clarify differences between the two classes of individuals plotted—males and females. Regression formulas for the two lines are an added refinement. (From R. Zweifel, *Amer. Mus. Novitates*, No. 1813 [1956].)

form of the number of individual animals in each class interval has been added above each bar of the histogram.

A much-used and adaptable form of bar diagram is one (Fig. 47) in which a line is used to represent the range of values of a series of observations, and appendages to that line illustrate other statistical data pertinent to the sample. Com-

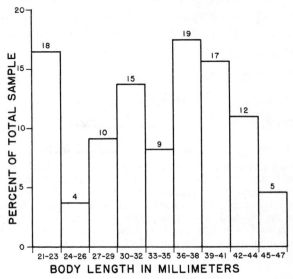

Fig. 46.—A typical histogram, based on the same data as Figure 44 and with the same axes. As an additional refinement, the number of individuals in each 3-millimeter size group has been indicated.

monly, a bar or crossbar at a right angle to the line represents the arithmetic mean, and rectangles on either side of the bar represent such statistical quantities as the standard error of the mean and the standard deviation or some multiple of these statistics.

This type of diagram is particularly useful where it is desired to compare several samples. In illustrating geographic variation, it is effective to combine this form of bar diagram

with a map, indicating the geographic origin of the several samples (see Fig. 53).

Bar diagrams may be used in a variety of ways to present and compare data. Figure 48 shows the relative importance of three principal prey species in the diet of several predators. The use of different shading patterns to represent the different prey species makes it immediately evident to the reader the status of each prey species in the diet of each predator. Also, it is possible to compare the food habits of the various predators, all of which live in the same region.

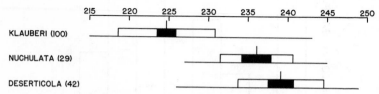

FIG. 47.—A very useful form of bar diagram, constructed in the manner advocated by Hubbs and Hubbs (*Syst. Zoöl.*, II, 49–56 [1953]). The long horizontal line indicates the range of variation in a given sample; the vertical line, the mean. In this example the statistical quantities of a standard deviation and two times the standard error of the mean on either side of the mean have been indicated by the light and dark rectangles, respectively. The graph is based on unpublished data for numbers of ventral scales in three subspecies of the night snake, *Hypsiglena torquata*.

Area diagrams.—The most commonly used area diagram is the pie or sector diagram, in which a circle is divided into radial sectors proportional in size to the values represented. An example of such a diagram is given in Figure 49. The data presented in this figure are the same used to construct the comparable part of the bar diagram in Figure 48. In drawing a pie diagram, the first radius is extended vertically upward from the center. If there are to be many radii converging at the center, a small circle may be cut out of the center of the "pie" in order to avoid congestion. A circular protractor is a most useful instrument to have on hand when drawing pie diagrams.

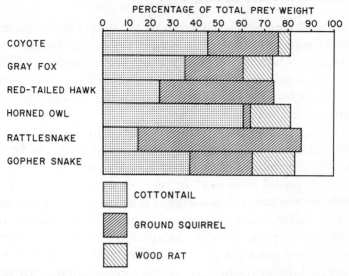

Fig. 48.—The use of shading patterns to differentiate segments in a bar diagram. The contrasting patterns make it possible to compare with ease the relative importance of a given item of prey in the diet of several species of predators. (Diagram based on data published by H. S. Fitch.)

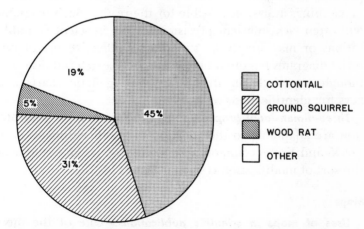

Fig. 49.—A pie (or sector) diagram illustrating the percentage of total prey weight of three important species in the diet of the coyote. These are the same data shown in the form of a bar diagram in Figure 48 and point up the superiority of the bar diagram where it is necessary to compare sets of data.

Pictorial diagrams.—This form of presentation of data utilizes pictorial illustrations in a variety of ways, often in conjunction with other types of graphs. For example, in a pie diagram, a drawing of the real object might be inclosed within each sector as a way of making plain the meaning of each sector.

Often a standardized picture is altered in size to indicate different quantities. This may be done *in toto,* the figure simply being magnified or reduced, or a standard-sized figure may be whittled away piece by piece. It should be noted that doubling the linear dimensions of a figure increases the area of that figure much more than twice. Properly, a figure intended to represent twice the quantity of another figure should show twice the area, not twice the linear dimensions. Disregard (or wilful neglect) of this consideration is particularly common in advertising art.

Generally speaking, pictorial diagrams find most use in popular or semipopular publications, where it is intended to make things as easy as possible for the reader. Such diagrams will often lack sufficient precision for use in scientific publications or may simply be superfluous. Effective use of pictorial diagrams has often been made in research publications, though, especially in illustrating phylogenetic charts and keys for identification.

Three-dimensional graphs.—Some types of graphic presentation are adaptable to the addition of another dimension to the X- and Y-axes common to so many graphs. An example of this sort of modification is seen in Figure 50.

Maps

Uses of maps in scientific publications.—One of the most important uses of maps is to illustrate the geographical distribution of kinds of organisms. This may be done in a general way by indicating with shading film the appropriate area of

the map where the animals or plants are found (Fig. 51). As an alternate method, the area where the organisms are not found may be shaded, and the area of occurrence left clear. Delimitation of the area to be shaded is, of course, the responsibility of the author. But the illustrator must exercise

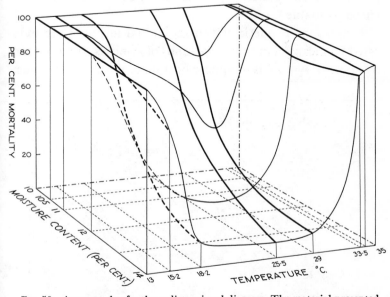

Fig. 50.—An example of a three-dimensional diagram. The material presented here could be shown in a series of five diagrams of temperature against percentage mortality (one for each level of moisture content), but the correlations among the three variables would be less easy to visualize. (From H. G. Andrewartha and L. C. Birch, *The Distribution and Abundance of Animals* [Chicago: University of Chicago Press, 1954].)

good judgment in the choice of the shading pattern. It must be bold enough to be clearly distinguished from other detail on the map and must be chosen with the reduction it will undergo in reproduction in mind. Often several different patterns will be required on a single map, and these must carefully be selected to be clearly distinguishable from one an-

other when reduced. If the illustrator's budget discourages the purchase of numerous shading patterns for a few small jobs, it is worth knowing that a pattern of parallel lines can be used satisfactorily to shade in four ways: with the lines horizontal, vertical, and on opposite diagonal slopes. Superposition of one pattern upon another adds to the variety of effects available.

A spot map is one in which individual localities are indicated by means of one or more kinds of symbols. If more than one type of symbol is to appear on a map, the symbols chosen

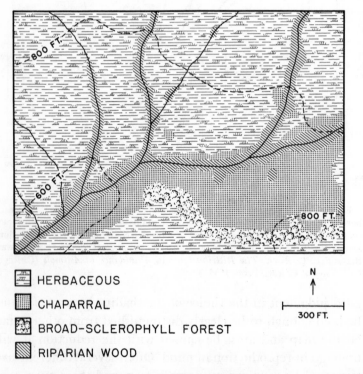

HERBACEOUS

CHAPARRAL

BROAD-SCLEROPHYLL FOREST

RIPARIAN WOOD

N

300 FT.

Fig. 51.—Illustrating the use of shading-film patterns in mapping, applied in this example to differentiating vegetation types.

must be sufficiently different from one another that they will readily be identifiable even when reduced.

An effective form of distribution map combines symbols and shading patterns. When drawing this sort of map, the illustrator must remember to remove the shading pattern on and immediately around each symbol, lest the symbol be obscured by the pattern (Fig. 52).

In mapping vegetation types and various other habitat classifications, the variety of shading-film patterns available will be found particularly useful. Often it is possible to find a pattern that will express the category pictorially. Patterns suggesting woodland, grassland, marsh, and water are among those available (see Fig. 10).

Selection of a base map.—The simplest form of map is an outline that shows nothing more than major physiographic boundaries or political subdivisions. Such a map is often used as a base upon which a figure for a biological illustration is constructed. At the outset the illustrator should be advised that, if he intends to use a commercially printed outline map as a base, he should take care to obtain written permission of the publisher of the base map before allowing it to appear in print, or a copyright infringement may result. Most often the artist who must prepare a map as a figure for a scientific publication will find it desirable to make his own base map. This may be done by utilizing the techniques of enlarging, reducing, and tracing, discussed in earlier chapters, on commercially available maps.

The base map upon which data are plotted must be selected with care. The first consideration is the elimination of superfluous detail. A base may be nothing more than a mere outline, or it may be as complex as a map showing topography (by contours or hachures), vegetation, and human cultural features of the landscape. Obviously, it will be best to include only such detail on the base as serves a useful purpose. Elabo-

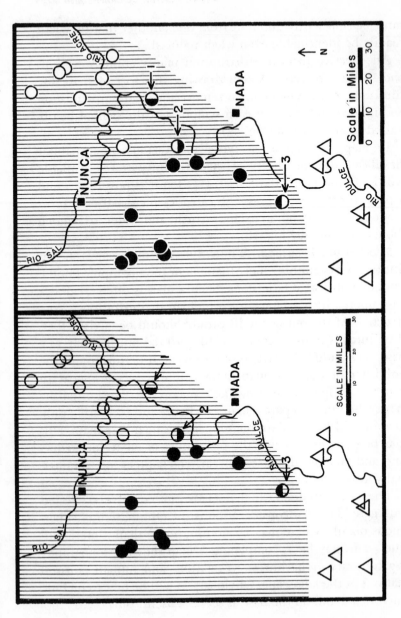

Fig. 52.—Some common errors in mapping. Note that, in the figure on the left, the numbers on the scale are lettered

rate detail of drainage systems might be entirely appropriate for a map showing the distribution of aquatic organisms but might be out of place on a map dealing with terrestrial animals. In the latter instance a few larger river systems (for purposes of orientation) might suffice. Also, the base should show no more area than is necessary; that is, it would be unwise to use a base map of North America to map the occurrence of a species confined to the West Coast. If it is necessary to show the relation of the West Coast region to the whole of the continent, this may be done in a small inset (see "Geographic Orientation").

Geographic orientation.—If the area mapped is restricted to a region that is not readily placed in its broader geographic context, a small inset map showing the area covered by the main map in relation to a larger, more familiar geographic area should be included. Thus a restricted area in, for example, Florida, is more easily visualized by the reader if an inset base map of the entire state is included.

In any map it is well to include some features that will allow geographic orientation, even though these features in themselves may not be of any significance to the basic purpose of the map. Cities, major political boundaries, or rivers may be useful in this respect. Lines of latitude and longitude may be indicated around the borders of the map or may, if they do not conflict with the material in the body of the map, be drawn across the face.

Compass direction.—It is a convention to orient a map with north at the upper edge. Occasionally, the dictates of space available for illustration and shape of the area mapped may suggest some other orientation. In either event, it is well to include on the map a simple marker such as an arrow indicating the direction of north.

Scale.—Every map, no matter whether the area is measured in square feet or thousands of square miles, should have the

scale indicated. Scale may best be shown graphically by means of a line or bar that is ruled or otherwise subdivided into segments proportional to the distance represented on the map and is drawn on the face of the map (see Fig. 51). Scale may also be indicated in words in the legend to the figure, as, for example, "2 inches:1 mile." The colon (:) means "is proportional to," and its use is preferred to that of the equals sign (=). A representative fraction such as 1/5,000 may also indicate scale, in this instance meaning that one unit on the map is the equivalent of five thousand units in the field (the map is one five-thousandths the size of the real area). The graphic method mentioned first has the distinct advantage that the scale undergoes reduction with the map when it is printed, being an integral part of the figure, since no recalculation of proportions is necessary. Also, the user of the map is saved the trouble of additional measuring or calculating.

Lettering.—The mechanical aspects of lettering are treated in chapter 6. To facilitate reading of the map, it is well to arrange the words parallel with the lower border of the map whenever possible. At times, however, lettering may more appropriately follow some natural physiographic feature, such as a mountain range or river. When a word on the face of a map is associated with a symbol, the lettering should be offset slightly to the right and below the symbol in order to avoid confusion of letters and symbol (see Fig. 52). It must be remembered that letters and symbols take precedence over other material on the map, and other lines should be broken where they conflict with letters and symbols.

Borders.—A single or double rectangular border is advised for any map. Where degrees of latitude and longitude are included, the numbers may conveniently be placed within a double border. Otherwise, a single border will suffice. Without a border, a map tends to look unfinished.

Combining graphs with maps.—Mention has previously been made of the use of graphs in conjunction with maps. The form of graph shown in Figure 53 is best adapted to illustrating geographical variation where the localities are arranged in a more or less linear fashion. Sector and bar diagrams may also be adapted for use with maps.

Overlays.—Sometimes it is necessary to publish a map or other graphic illustration that will be reproduced as a line cut in two or more colors; for example, a map in which features of drainage are important might emphasize the rivers and lakes in blue, the remainder of the map being in black and white. The illustrator draws the lines to be printed in black in the usual fashion on a standard ground such as Bristol board. The lines to be reproduced in blue are then drawn on a transparent ground such as vellum, tracing linen, or acetate. Using a transparent ground, the artist can place it over the black-and-white base and keep a check on the accuracy of the overlay. The use of an opaque ground for both copies, sometimes necessary, requires greater care in making the overlay.

Both base and overlay should have registration marks placed in the corners outside the field of the figure. These must be placed so that, when the registration marks of the overlay coincide exactly with those of the base, the overlay figure falls exactly in place on the black-and-white base. The paper has to be run through the press once for the base and an additional time for each overlay color. The registration marks are the guides that allow the pressman to insure accurate register in the two or more printings.

The overlays may be drawn in black ink or in color, depending on the desire of the illustrator and engraver. Some engravers require the use of black ink and a written indica-

tion of the color of ink to be used in printing. An advantage of drawing the overlay in the final color is the ability to see immediately the effect of the finished product. Of course, colors that will not reproduce in the line-cut process cannot be used. In addition to colored inks, the artist may wish to take advantage of colored shading films (p. 81).

Fig. 53.—The form of bar diagram shown in Figure 47 is well adapted to illustrating geographical variation where the samples are arranged in a more or less linear fashion. (Data from R. G. Van Gelder, *Bull. Amer. Mus. Nat. Hist.*, Vol. CXVII, Art. 5 [1959].)

Selected References

Musham, H. A. *The Technique of the Terrain.* New York: Reinhold Publishing Corp., 1944.

Ridgway, John Livesy. *Scientific Illustration.* Stanford, Calif.: Stanford University Press, 1938.

6 *LETTERING*

Introductory Remarks

Many biological illustrations will require lettering. Parts and points of interest in drawings will be labeled; graphs and maps will need numbers, place names, legends, and titles. Even some tables will have to be lettered, though these are more usually set in type. It is no exaggeration to say that the quality of lettering of an illustration plays a major role in the general appearance of the illustration, even though the lettering may represent a minor part of the illustration in terms of area covered and effort expended. It behooves the illustrator, then, to pay particular attention to the production of neat, attractive lettering.

Some editors prefer that the artist do no lettering at all on any illustration. They request the use of an overlay sheet to indicate the position and wording of legends, labels, and directions of all kinds, which will be set in type by the printer. The overlay sheet may be tracing paper, tracing linen, or acetate or polyethylene film. The artist must place register marks on the illustration outside the margins of the drawing and must put corresponding register marks on the overlay sheet. Unless the register marks meet exactly, the labels will be printed out of position on the illustration. (See p. 101 for making an overlay.)

Size of lettering.—Lettering should not look out of place by being either so large as to crowd the field or so small as to leave useless and distracting blank areas. The use of different sizes of lettering is one way of categorizing subjects in an illus-

tration. The illustrator must be careful to make the lettering of such a size that it will be no less than $1\frac{1}{2}$ millimeters high when reduced for publication. It is possible to reduce this size limit slightly if highest-quality reproduction is assured, but low-budget scientific publications seldom feature the best possible reproduction.

Lettering on the drawing and pasted lettering.—Lettering may be done directly on the drawing or may be done on a separate sheet of paper and later pasted in place. Each method has its advantages and disadvantages. In general, it is easier to letter on a separate sheet of paper and then attach the lettering in its appropriate place. The possibility of accidental ink spillage or smearage on the drawing is eliminated, centering of words and phrases is facilitated, and such mistakes as might be made are of less consequence than they would be if made directly on the drawing or other illustration being lettered. Because of the danger of detachment and loss, however, some editors refuse to accept illustrations with pasted labels. Another disadvantage is that shadow lines from the labels may appear on the engraving. For this reason, it is well not to paste labels too close to lines drawn on the illustration, as the shadow and line may become confused, necessitating extra costly work by the engraver.

Instead of doing the lettering himself, the illustrator may wish to make use of prepared letters. Sheets of letters and numbers may be purchased, and the letters can be cut out and pasted in place on the illustration. An easier method is to use a commercial product in which the letters are printed on an adhesive transparent base. Two such products are Para-Tipe and Artype, in which alphabets, arrows, numerals, border lines, and symbols are printed in black or white on wax-adhesive or heat-resistant adhesive transparent film. To make a line of lettering, the illustrator draws a guide line in faint pencil or blue pencil on his copy and cuts the desired letters

from a large sheet of the film with a teasing pin, needle, or X-acto knife. The cutout letters or symbols are pressed and burnished into place in the same way as Zip-a-Tone (see pp. 80–83). The range of sizes and styles of print is very wide. Some letters and symbols may be had in opaque white on a black background or outline or in black with white background, outline, or shading. Fancy borders and styles of print are useful on such specialized places as chapter headings. Tedious lettering that might require hours to do by hand may be finished in much shorter time.

If only a few numbers or letters are needed, the illustrator may find it practical to cut them from a calendar printed in black or from a magazine or similar source.

Freehand Lettering

There are some advantages to freehand lettering over preprinted lettering or that done with a mechanical device. It can be accomplished more quickly than mechanical lettering, the results can be more lively, and any desired style may be used. Unless the illustrator is highly skilled, however, his hand lettering is likely to be uneven and unattractive.

Materials needed for freehand lettering include a drawing board or table, preferably one that can be tilted; a penholder with a variety of pens, including square-cut lettering pens, rigid drawing pens, and fine, flexible pens; a few pencils; waterproof India ink; paper; a rule; and soft erasers or carbon tetrachloride to remove pencil lines.

Guide lines are required for neat freehand lettering. Graph paper ruled with light-blue lines is good for planning the lettering before it is applied to the copy and may be used as the base for pasted lettering. In preparing to letter on copy, the illustrator decides the desired size and spacing of his lettering and then carefully rules lines in pencil to guide the lettering. The guide lines are drawn parallel to each

other, inclosing the letters and words (Fig. 54). A railroad pencil, which draws two lines at once, will facilitate the ruling of guide lines, since only the base will require measurement. The railroad pencil is especially helpful where the lettering must follow a curved line, as is sometimes true on maps. A lettering triangle may be used with a set of ship's

FIG. 54.—Examples of freehand lettering. The original copy was done on blue-lined graph paper with a broad lettering pen. Note, at the top of the figure, the arrows indicating the directions to move the pen for different strokes. Note also the use of guide lines. Reduced one-half.

or French curves to produce parallel curved lines if a railroad pencil is not available.

Before using pen and ink, it is well to plan the lettering on the copy in pencil. If the pen is equipped with a reservoir, it is filled not by dipping but by placing a drop of ink in the reservoir with a dropper (often built into the cap of the ink bottle) or inexpensive brush. Dipping a reservoir pen may result in drawing an uneven line. When in use, any pen should be wiped frequently on a chamois or lint-free

cloth. The square-cut pen is used to draw both wide and narrow lines. The rigid drawing pen will produce a narrow, unvarying line. The fine, flexible pen is not used to make letters but is useful for touching up lettering done with rigid pens.

Letters are made by drawing the pen toward the worker, even if this means picking up the pen to complete the letter (see Fig. 54). Pushing the pen will result in digging holes in the paper or spattering ink over the copy. Light pencil lines that remain visible after lettering can be removed with a soft eraser or by wiping the copy gently with a piece of cotton moistened with carbon tetrachloride. If the inked lettering is lightened by the erasure, the unsatisfactory letters should be retouched. To do this, the illustrator should use a fine, flexible pen and draw in the middle of the previous line. This will flood the line without widening it. Use of the fine pen to strengthen lines is recommended also for mechanical lettering or any ink rendering. Blots, unwanted lines and letters, and parts of letters may be painted out with dense white gouache.

The value of practice in lettering cannot be overstated. In addition to learning merely the facile manipulation of the pen, the illustrator who will produce high-quality free-hand lettering must develop an eye for balance between size and shape of letters and heaviness of line. (If the reader wishes to go more deeply into the subject of freehand lettering, he may refer to the book listed in the Selected References at the end of this chapter.)

Mechanical Lettering Systems

The chief advantage of using a mechanical lettering aid is that the lettering will be uniform, and a person unskilled in freehand lettering can produce neat, attractive work with

only a little practice. The most evident disadvantages are that lettering may go somewhat more slowly than it would for an illustrator adept at freehand lettering, and the cost of at least the more elaborate lettering devices is more than one who letters only occasionally may wish to invest.

The deservedly most popular type of mechanical lettering device employs templates and a scriber (Fig. 55). One arm of the scriber is tipped with a metal point that fits into the

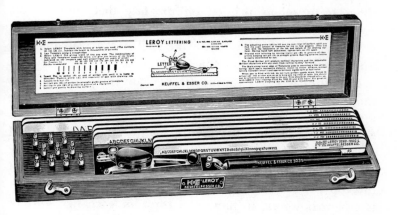

Fig. 55.—Leroy lettering set. (Courtesy Keuffel & Esser Co.)

letters and numbers depressed into the template; a second arm, also with a metal point, fits into a guide groove in the template; the third arm of the scriber holds an inkwell point or a graphite point. By moving the first scriber point within the letters in the template and moving the template along a stationary guide bar, the illustrator may produce a straight line of lettering with comparative ease. The simplest scribers can make only vertical letters. A scriber with an adjustable arm can produce slanted letters, and more complex scribers are available that can make tall or short, vertical or sloping, letters with a single template.

Templates are available with letters of different sizes, with numbers, and with various symbols. Capitals, lower-case letters, and numbers may be had on one template, or templates with only capitals and numbers are available. In addition to conventional block letters, many styles of type face are offered, such as Old English, Gothic, Caslon, and script. A variety of templates have symbols for maps, geology, mathematics, music, and other special subjects. Custom-made templates are available on special order. Templates are identified by numbers printed on the face that indicate the height of a vertical letter in thousandths of an inch.

Inkwell points for use with the scriber are available in a number of sizes to draw lines of a great variety of widths.

Use of the scriber lettering device is not complicated. First, the illustrator constructs a base for the template by securing a rule at both ends to the drawing board. Masking tape is applied to the rule, as shown in Figure 56. This will hold the rule in position and yet allow the copy to be moved freely beneath it. If the rule does not extend beyond the edges of the copy, it may be carefully taped directly to the copy. It is easier, however, to move the copy for each new row of lettering than to move the base rule. One brand of lettering device features a base rule with a non-skid backing that reportedly does away with the need for taping the base to the board or copy.

The choice of inkwell point is dictated by the size of the letters. The appropriate point for proper balance of line width with letter size is indicated on the template. After the point is fitted securely in the scriber, it is filled with India ink by means of a dropper, until the ink level reaches slightly above half the depth of the well. If the ink will not flow at first, lift the point within the well slightly and then drop it back in place. The proper flow of ink is determined by adjusting a screw that raises or lowers the arm holding the

point, regulating the pressure of the point on the drawing surface. With the pressure properly set, pen filled, and the base rule secured, lettering can begin.

The chosen template should be placed against the base, one point of the scriber in the desired letter of the template, and the tail point in the guide groove. The scriber should be moved so that the template point follows the depressed letter, and the letter will be drawn by the ink point. At the completion of each letter, the template should be moved

A

B

C

Fig. 56.—Preparation of a base rule for use with a scriber lettering system. *A*, The first strip of gummed tape is applied to the underside of the rule, with an inch extending from the end of the rule. *B*, The second piece of tape is applied, gummed sides together, to the exposed end of the first piece. *C*, The rule is taped to the drawing board, ready for paper to be slipped under.

along the base until the next letter is in position (see Fig. 57).

Where spacing of words and letters is critical, it is desirable to letter first with graphite in the scriber in place of the ink-well point. When the proper composition is achieved, the lettering may be repeated in ink. An instance where preliminary lettering is recommended is in mapping, where a word may be set to the left of a point. Usually, it is better in this case to letter backward, starting with the last letter, in order to achieve the correct spacing. When using a lettering device, a person tends to concentrate on letters rather than on words, and so mistakes in spelling are a common consequence that must be guarded against. Here, again, preliminary lettering in graphite is helpful.

When a line of lettering is completed, the copy is moved up to the proper position for the next line. Work proceeds from top to bottom of the copy to prevent smearing the ink.

The two leading scriber lettering systems are the Leroy System (Fig. 57) and the Wrico Scriber Lettering System. The lettering sets may be bought as units or piece by piece. Both systems include an inkwell point-holder that is designed for use with an ordinary penholder. This is an invaluable aid when ruling lines, drawing through stencils, and applying stipple dots of uniform size. The Wrico set includes a non-slipping guide-holder (base rule). Leroy points are somewhat easier to use and clean.

Leroy and Wrico lettering sets are relatively expensive, with a basic set costing about fifty dollars. The purchase of additional templates can double the price. An illustrator who does a large amount of varied biological illustrating will probably find one of these more elaborate sets a good investment. For the person who needs to letter only occasionally, there are perfectly satisfactory substitutes that permit neat lettering without the variety of size, upper and lower case, italics, and symbols provided by the expensive sets.

The Doric lettering set (see Fig. 58) is the inexpensive student model of the Leroy System. It is equipped with one template having three sizes of numbers, upper-case letters, and several punctuation marks and symbols, including parentheses. The templates, scribers, and points are not inter-

Fig. 57.—Hand and scriber, Leroy System

changeable in Leroy and Doric sets, but the Doric points may be used in the Leroy socket-holder with a freehand pen.

The Zephyr lettering set is an inexpensive model made by the Wrico firm. It includes one template having three sizes of upper-case letters, numbers, and various symbols, but not including parentheses. A non-slipping guide-holder is included.

The lettering sets discussed above are basically similar in ease of operation and quality of results they will produce.

DORIC 100

ZEPHYR 140

DORIC 140

ZEPHYR 175

DORIC 240

ZEPHYR 240

A

DORIC 100

ZEPHYR 140

DORIC 140

ZEPHYR 175

DORIC 240

ZEPHYR 240

B

DORIC 100

ZEPHYR 140

DORIC 140

ZEPHYR 175

DORIC 240

ZEPHYR 240

C

FIG. 58.—Examples of scriber lettering using the Doric and Zephyr systems. *A*, Original size. *B*, Reduced one-third. *C*, Reduced one-half.

There are slight differences in details of manufacture, sizes of lettering, and variety of templates available (in the inexpensive sets only a single template is available). The prospective purchaser would do well to work with each of the sets for a time before choosing.

There are various mechanical lettering devices other than the scriber systems. In general, these alternative devices are more difficult to use in comparison with scriber systems, and the results are less satisfactory.

Care of lettering devices.—India ink is used with all lettering devices, and, because it clots as it dries, the points must be cleaned thoroughly. Usually, rinsing the point with cool running water immediately after use will keep it clean. If a point has been clogged with ink, it should be soaked in pen-cleaning fluid. This cleaner may be bought ready-made or may be made by adding a little ammonia to a solution of pure soap and water. Commercially prepared cleaner should be diluted with an equal volume of water before use. Prolonged soaking of the point may ruin it; overnight is quite long enough to soak a badly clogged point.

Selected References

Higgins Ink Co., Inc. *Lettering.* Brooklyn: Higgins Ink Co., Inc., 1959.

7 ILLUSTRATIONS FROM PHOTOGRAPHS

This work does not include a discussion of the use of photographs, as such, for illustrations. It does, however, cover two other areas in which the scientific illustrator may find it necessary or desirable to work with photographs. Often the appearance and usefulness of a photograph can be improved by retouching. A second and important use of photographs is as the base upon which a drawing is constructed.

Retouching Photographs

Minor retouching is not difficult, but, unless the illustrator is skilled in the use of an air brush, he should not attempt retouching that requires coverage of large areas. As a rule, photographs are reduced at least one-half in the final published form. For convenience in retouching, it is often well to work on a print three to four times the expected final publication size. At least two and preferably more prints should be on hand. One will be the actual working print; the second serves as a reference, so that the worker may be continuously aware of to what degree he has changed the original; additional prints serve as spares in the event of an unsatisfactory first rendition (Figs. 60 and 61).

Special retouching kits are sold at photographic supply stores. Such a kit contains various dyes appropriate to different photographic-paper emulsions and a sheet of instructions giving exact details on use of the dyes. The retoucher will need eyedroppers, mixing dishes, and good-quality watercolor

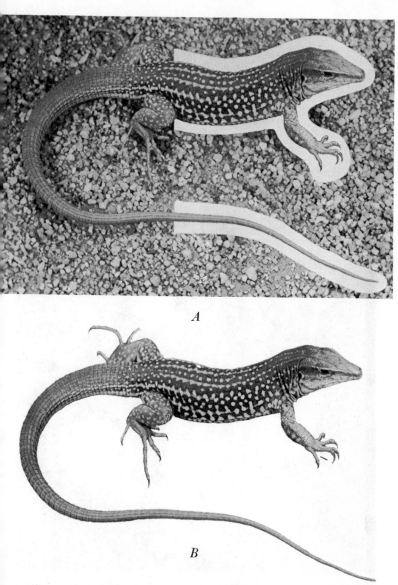

A

B

FIG. 59.—Silhouetting a photograph to remove unwanted background. *A*, One-half of the lizard (*Cnemidophorus burti stictogrammus*) has been outlined carefully with per-white gouache paint. *B*, After the lizard was completely outlined, the engraver as able to remove the rest of the background. (Courtesy American Museum of Natural History.)

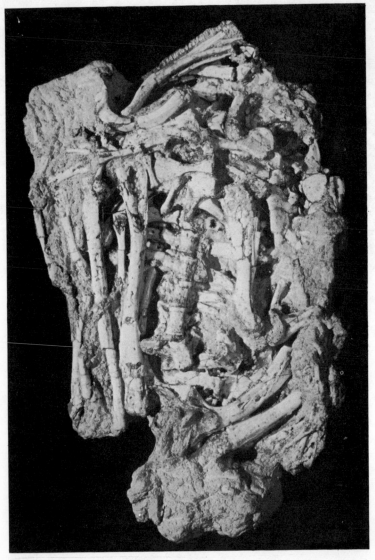

FIG. 60.—Original photograph of a fossil frog, *Eopelobates grandis*. (Courtesy American Museum of Natural History.)

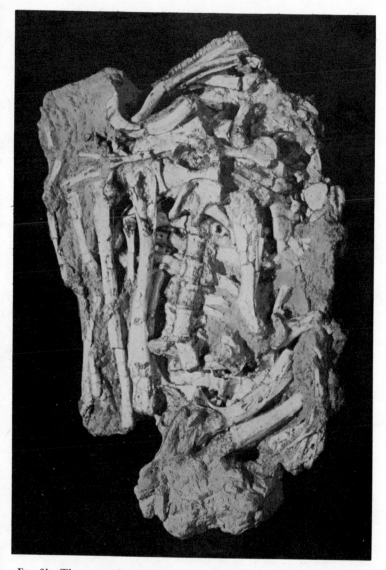

Fig. 61.—The same photograph as Figure 60, retouched to help differenti-
ate between bone and matrix. (Courtesy American Museum of Natural History.)

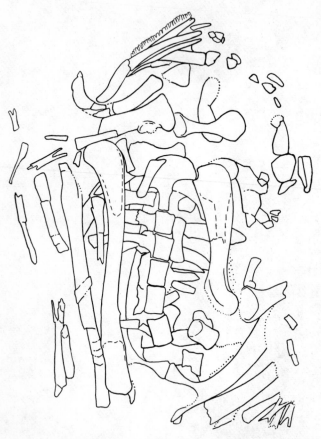

Fig. 62.—Drawing made from a photograph (the one seen in Fig. 60). The drawing was done on the photograph itself with waterproof ink, and then the photograph was completely bleached out.

brushes. The dyes may be used on glossy as well as matte prints.

If retouching dyes are not available, the artist may use other materials and methods. Hard- and soft-lead pencils, charcoal pencils, and white Conte pencils are used on matte-surface prints to emphasize or minimize textures and highlights and to bring obscure portions of the picture into prominence.

The illustrator holds the pencil lightly and touches the photograph with soft, short brushing strokes. To make an area darker (or lighter, using a white pencil), individual strokes are not drawn more heavily; rather several strokes are applied one over another. This gradual building-up process lessens the chance of mistakes and erasures which tend to make an illustration look ragged. Careful smudging may be employed so that individual strokes will not be apparent in the finished illustration. Smudging must be applied sparingly, though, as too much can cause a dull and amateurish look.

Matte-surface photographs may be retouched with gouache paints if desired, but pencils usually give better results. When paints are used, small areas may be blotted and lightly smudged with absorbent cotton or tissues to blend the edges of the paint. The illustrator must be extremely careful to match the hue of the paint to that of the photograph, since the photograph may be slightly blue or brown. Unmatched paint is glaringly obvious.

Glossy prints make sharper illustrations than matte prints, but they are decidedly more difficult to retouch. If the illustrator is unable to use a matte-surface photograph, he may have to retouch a glossy print by means of gouache paint. The gloss can be diminished by gently rubbing the surface with drafting powder or by spraying on a thin film of dulling spray. One such film is made by Krylon and dispensed

in pressure cans. The paint is mixed with pure black and absolute white to the desired shade of gray; any cream or brown tint will be very obvious in the printed photograph. The value of the paint should exactly match the part of the photograph to which it is applied. The gouache paint should be applied carefully and sparingly and should not be too thin. Blotting the wet paint with an absorbent tissue will lessen the "painty" appearance, or the damp paint may be blended into the picture with the finger. It may be "erased" by washing it out with a brush and clear water, but the wet paper should be blotted immediately to prevent warping.

If the illustrator does not wish to use gouache, India ink mixed with Ivory soap will adhere to glossy prints. The ink-soap mixture is used to draw very dark lines, dots, and such. There is a commercial ink especially suited to drawing on glossy-print surfaces.

It is sometimes desirable to remove all background material in order to have the subject stand out as a silhouette against a white or black background. This can be done by painting the entire background of the photograph, but it is more effectively accomplished when the engraving is made. The illustrator paints a band of opaque white or black around the periphery of the subject, taking care to follow the margin of the subject exactly. The paint must be dense enough that no trace of the underlying photograph shows through. The figure is delivered to the engraver with instructions to prepare the plate as a silhouette. Using the illustrator's painted margin as a guide, the engraver will tool away all excess material on the plate (Fig. 59).

The illustrator should strive to make his retouching as unobtrusive as possible. The highest praise that can be given a retouched photograph is to have the retouching not be recognized.

Lettering on Photographs

It will often be found necessary to number or letter on the surface of a photograph. This may be done directly by hand or (preferably) with a lettering set, but several alternative methods are available. The letters may be drawn on a separate piece of paper and then pasted into place, in which case they will appear in the center of a clear space. Commercially prepared letters and numerals printed on gummed paper or clear, adherent film may be used. In lieu of these, letters and numerals cut from a calendar or similar source of uniform printing serve as convenient substitutes. Lettering placed directly on the photograph may tend to disappear into the background unless it is shadowed on one side—with white in dark areas if the lettering is black, and with black in light areas if the lettering is white.

If a glossy photograph is covered with Copy-Zip, a clear, matte film, the surface is made ideal for inking without injuring the quality of the photograph for reproduction.

Drawings from Photographs

Photographs, retouched or not, are reproduced by halftone, offset, or collotype. In order to reproduce at a lower cost or to omit unwanted and unnecessary details, the illustrator may wish to make an exact line drawing from a photograph. He may either trace the photograph or draw directly on it.

A tracing table will greatly facilitate the task of tracing a photograph. Good-quality tracing paper, tracing linen, or acetate film is used. The tracing should be done lightly with a hard pencil, with all the lines to be inked carefully planned in pencil. The inking should be done using the photograph as a reference, not with the tracing still over the photograph. An opaque projector can be used to enlarge and trace a photograph at the same time (see Fig. 16).

A second method of making an accurate line drawing from a photograph involves drawing directly on the photograph and then bleaching away all but the inked lines (Fig. 62). The illustrator uses a waterproof ink, such as Higgins American India Ink or an ink made especially for this purpose and obtainable from a photographic supply store, and draws his lines and stipple directly on the photograph. He should have at least two prints on matte paper, printed quite pale so that the drawn lines will show clearly. After the ink has dried, the illustrator bleaches out the photographic material. The bleach is made of sodium hyposulfite and potassium ferricyanide, which can be obtained from a photographic supply store. These powders are mixed separately, about a teaspoonful of powder to one or two tablespoons of water. The solutions are then mixed and painted over the photograph. The yellow deposit left by the bleach must be washed off with clear water.

"Photo sketches" such as these will be reduced for publication as line cuts like any other pen drawing; the illustrator must use photographs enlarged accordingly.

Selected References

COLBERT, EDWIN H., and TARKA, CHESTER. "Illustration of Fossil Vertebrates," *Medical and Biological Illustration* (London), X, No. 4 (1960), 237–46.

RIDGWAY, JOHN LIVESY. *Scientific Illustration*. Stanford, Calif.: Stanford University Press, 1938.

8 MOUNTING AND HANDLING ILLUSTRATIONS

Finished illustrations must be protected from smudging, dirt, and breakage. This is accomplished by mounting them on firm board, if not already drawn on such a ground, and by providing a permanent or removable protective covering.

Mounting Illustrations

An illustration done on a flexible or fragile surface or on one that is likely to warp should be attached to a mounting board such as stiff, white poster board. The board should be cut somewhat larger than the dimensions of the illustration to be mounted. When small illustrations are submitted with a manuscript, it is often convenient to cut the mounting board to a size of $8\frac{1}{2}$ by 11 inches, to conform to the size of manuscript paper and envelopes.

The choice of adhesive will depend primarily upon whether a permanent or a temporary mounting is required. For temporary attachment, rubber cement is the adhesive most widely used. It is definitely temporary and should not be employed when the mounting must last for more than several months. Rubber cement is applied in a thin, even coat to the back of the illustration and to the mounting board. After the cement is allowed to dry for a moment, the illustration is pressed gently and smoothly into place. With light pressure and a clean cloth any excess cement may be rubbed off after it dries. Since rubber cement may yellow with age, it should not be allowed to remain on the surface of an illustration. An illustration mounted in this manner will lie flat for

reproduction and yet will be removable from the mount if necessary.

Mounting that is to last for more than a few months requires a more permanent adhesive. White casein glue is an adhesive that is stronger than the paper it binds; the illustration will tear if an attempt is made to remove it. The illustration should be smeared with a thin coat of glue and applied to the mounting board, with firm pressure continued for several minutes until the glue sets. If the glue is applied to the entire back of a piece of thin paper, the paper may buckle. This will not happen with rubber cement.

The most permanent and smoothest mounting is achieved with dry mounting tissue, available in sheets and rolls at photographic supply stores. Use of this tissue requires a heat source that may conveniently be furnished by an ordinary household flatiron. Irons and presses specifically designed for use with mounting tissue are also sold.

A sheet of tissue is cut exactly to fit the copy to be mounted. The tissue is "tacked" to the back of the copy at two corners with the iron. The illustration with attached tissue is then placed in the position it will occupy on the mounting board and the same two corners tacked down, with a piece of paper placed for protection between the iron and the face of the illustration. The mounted illustration is then placed, face up, on a piece of felt or blanket on a flat surface. With a clean blotter covering the illustration, the flatiron (heated to 175° F.) is pressed down on the blotter for 1 minute.

This method of mounting is equally well adapted to use with photographs and the several artist's grounds. It should not be used to mount illustrations employing grease or wax pencils, such as Ross and Coquille board illustrations or wax-adhesive shading films.

Protecting Illustrations

Pencil and charcoal drawings are easily smudged; a careless scratch can injure a scratchboard drawing; accumulated dust, dirt, and spilled ink can destroy the work of hours or days. It is thus essential that an illustration, once completed, be provided with some protection against these eventualities.

A form of protective covering for any pencil, charcoal, pastel, or ink work that has come into wide usage in recent years is clear plastic, sprayed over the work from a pressure can. The fixative is applied by spraying from a distance of 1–2 feet onto the upright illustration, sweeping lightly over the surface with several applications. This type of fixative, because of its convenience of use, has largely replaced other types applied with sprayers operated by means of the breath, squeeze bulb, or pump ("Flit" gun).

Casein and oil paintings are customarily protected by varnishing their surfaces.

In addition to covering their surfaces with plastic spray, it is generally well to provide additional protection for illustrations in the form of an opaque or transparent covering sheet. Heavy brown wrapping paper serves for most purposes, but, where transparency is needed, a sheet of acetate is used.

The wrapping paper is cut to the width of the mounted illustration and 2 or 3 inches longer than its height. The paper is attached to the back of the mounting board near the top with masking tape and then folded over the face of the illustration. If the illustration is to be referred to frequently, the brown paper may be trimmed to the bottom edge of the board and left free; otherwise it is folded under and taped in place. An acetate sheet is best cut to the exact size of the mounting board and taped down at the top and bottom edges.

Identifying Illustrations

An illustration should have an identifying phrase or legend written on it or, when mounted, on the board. This is particularly important where some confusion among specimens illustrated might arise.

Writing on the back of an illustration may be in lead pencil, but any writing on the face of the drawing or mounting board should be in light-blue pencil. Writing on the back of a photograph should be avoided. If such writing must be done, use a soft pencil and back up the photograph with a hard surface such as glass. If writing is done on a soft surface, ridges that interfere with best reproduction appear on the face of the photograph. For a similar reason, a separate legend should not be attached to a photograph with a paper clip.

Identification on an illustration should include the name of the artist and of the person for whom the work was done (if not the artist), the name of the publication for which the illustration is intended, the subject of the illustration, and, if appropriate, the scale of the drawing and suggested reduction.

Mailing Illustrations

If it is necessary to send illustrations by mail, the artist should assume that "Fragile" and "Handle with Care" stickers will be ignored and pack accordingly. Most work done on standard grounds will be adequately protected if inclosed in a sandwich of heavy corrugated cardboard cut slightly larger than the largest illustration, with the whole package wrapped in a double layer of heavy brown paper.

INDEX

[An asterisk (*) indicates an illustration]

Acetate grounds, 45, 61, 62, 72, 127
Adhesives: casein glue, 126; dry mounting tissue, 126; rubber cement, 125
Aerial perspective, 27, 28*
Anesthetizing animals, 43
Area diagram, 92, 93*
Artistry, 29

Bar diagram, 90, 91*, 92*, 93*
Black-and-white illustrating, v, 45–62
Blocking-in, 31, 33*, 44
Blueprinting, 2
Brown printing, 2
Brushes, 64*, 66; oil, cleaning of, 68

Calipers, 30
Camera lucida: microscope, 40, 41; regular, 35–37*
Casein painting, 22, 68
Charcoal drawing, 21, 62
Collotype, 11
Color illustration, vi, 22, 66–68
Color reproduction, 12, 13
Color transparencies, 13
Compass direction, on maps, 99
Co-ordinate squares, 34–36*, 39
Copper cut, 5, 8*
Copying, vi; see also Pouncing; Tracing
Copyright, vii, 97
Coquille board, 5, 44, 53, 54*
Crosshatching, 52*, 53

Diagrams: area, 92; bar, 90; line, 88; pictorial, 94; pie, 92; scatter, 85; sector, 92
Dividers, 30*
Drop-compass, 79*
Dry-brush rendering, 21, 55, 56*
Dummy plate, 18

Enlarging: by co-ordinate squares, 34–36*; by projector, 40, 41*

Fixatives, 64
Frequency polygon, 88*, 89*

Geographic orientation, 99
Gouache painting, 22, 67, 121
Graph paper, 71, 72, 85
Graphs, 23, 71, 85; three-dimensional, 94, 95*
Grounds: acetate, 45, 61, 62, 72, 127; Coquille board, 5, 44, 53, 54*; graph paper, 71, 72, 85; polyethylene, 61, 62, 72; scratchboard, 5, 7*, 28*, 55, 57, 58*, 59*, 60*, 64*; stipple board, 5, 15*, 44, 54*

Halftone, 5, 6, 9*, 10*, 117*, 118*, 119*
Hatching, 50–52*, 53
Hectograph, 2
Histogram, 90, 91*

Illumination, of subject, 49
Ink, 73
Ink rendering, 20; see also Pen-and-ink drawing

Labeling illustrations, 128
Latitude, allowable, 28
Legend, allowance for, 16
Lettering: devices for, 79, 108, 109*, 110–14*, 115; freehand, 106, 107*; on maps, 98*, 100; materials for, 23; pasted, 105; on photographs, 123; prepared, 105, 106; size of, 104, 105
Line cut, 4, 5, 7*, 8*, 120*
Line diagram, 88*, 90*
Linear perspective, 27
Live animals, 43

Magnification: determination of, 39; stating of, in figure legend, 40
Maps, 94–96*, 97, 98*, 99–101*, 102*; borders for, 100; combined with graphs, 101, 102*; compass direction on, 99; geographic orientation of, 99; lettering on, 71, 100; materials for, 23; scale of, 99, 100; selection of base for, 97; spot, 96; use of, in scientific publications, 94
Measuring, 29, 30*, 32
Microprojector, 41, 42*
Microscope, 39
Mimeograph, 1
Mistakes, correction of, 68, 69, 108
Moire effect, 6, 10, 11
Mounting illustrations, 24, 125
Mounting tissue, 126

Offset reproduction, 11
Oil painting, 22, 68
Overlays, 101, 102; lettering, 104
Ozalid, 2

Pantograph, 37, 38*
Parallax, vi, 32, 34*, 35*
Parallel lines, 76, 77*, 78
Pen-and-ink drawing, 7*, 8*, 28*, 33*, 34*, 36*, 45–47, 48*, 49*, 52*, 120*
Pencil drawing, 20, 63, 64
Pens: Leroy, 72, 73, 74*, 78, 79; preparation of, 47; railroad, 72; ruling, 72

Perspective: aerial, 27, 28*; linear, 27
Photoengraving, 4
Photographic printing, 3
Photographs, vi, 5, 6, 39; bleaching of, 124; drawing from, 120*, 123, 124; lettering on, 123; retouching of, 116, 119*, 120*, 121; silhouetting, 117*, 122
Photostat, 2
Pictorial diagram, 94
Picture plane, 32, 34*
Pie diagram, 92, 93*
Polyethylene grounds, 61, 62, 72
Poster paint; *see* Gouache painting
Pouncing, 84
Printer's measure, 15
Proportional dividers, 30, 31*
Protecting copy, 127

Railroad pen, 72, 73*
Railroad pencil, 72, 107
Reducing lens, 19
Reduction: amount in reproduction, 14; desirability of uniform, 18; directions to printer, 14, 15*; by graphic method, 30; by projector, 40, 41*; reasons for, 14
Register, 13, 101
Retouching dyes, 116, 121
Retouching photographs, 23, 116, 119*, 121, 122
Rubber cement, 125
Rules: curved, 75*, 76; straight, 75, 80*
Ruling pen, 72, 74*

Scale, on maps, 99, 100
Scatter diagram: polar, 87*; rectangular, 85, 86*, 90*
Scratchboard, 5, 7*, 21, 28*, 55, 57, 58*, 59*, 60*, 61, 64*
Screen, 6, 9*, 10*, 11, 66
Sector diagram, 92, 93*
Shading convention, 26
Shading patterns, 5, 29, 80, 81*, 82, 83*, 84, 94–97, 102
Showcard color; *see* Gouache painting

Silhouetting photographs, 117*, 122,
Size, of copy, 14, 16, 17*, 18
Smudging, 63*, 69, 125
Stencil copying, 1
Stipple board, 5, 15*, 44, 54*
Stippling, 8*, 50, 51, 66
Supporting an object, 42
Symbols, 78, 79, 96, 97

T-square, 75, 76
Telescope, 34, 35*

Templates, 79, 80, 111–13, 115
Three-dimensional graphs, 94, 95*
Tracing, 45
Tracing linen, 45
Tracing table, 45, 123
Transferring, 45, 84

Wash drawing, 9*, 22, 64–66
Watercolor painting, 22, 66, 67

Zinc cut, 5, 7*

PHOENIX BOOKS

P 1 *Ernst Cassirer, Paul Oskar Kristeller, and John Herman Randall, Jr.*, EDITORS:
 The Renaissance Philosophy of Man

P 2 *Edward Chiera:* They Wrote on Clay

P 3 *John Dewey:* The Child and the Curriculum *and* The School and Society

P 4 *Friedrich A. Hayek:* The Road to Serfdom

P 5 *Jacques Maritain:* Man and the State

P 6 *Anselm Strauss*, EDITOR: The Social Psychology of George Herbert Mead

P 7 *Louis Wirth:* The Ghetto

P 8 *T. V. Smith*, EDITOR: Philosophers Speak for Themselves: From Thales to Plato

P 9 *T. V. Smith*, EDITOR: Philosophers Speak for Themselves: From Aristotle to Plotinus

P 10 *A Professional Thief:* The Professional Thief, *edited by Edwin H. Sutherland*

P 11 *John A. Wilson:* The Culture of Ancient Egypt

P 12 *Gilbert Murray:* The Literature of Ancient Greece

P 13 *Ernest Staples Osgood:* The Day of the Cattleman

P 15 *R. S. Crane*, EDITOR: Critics and Criticism (*abridged*)

P 16 *Karl Löwith:* Meaning in History

P 17 *T. V. Smith and Marjorie Grene*, EDITORS:
 Philosophers Speak for Themselves: From Descartes to Locke

P 18 *T. V. Smith and Marjorie Grene*, EDITORS:
 Philosophers Speak for Themselves: Berkeley, Hume, and Kant

P 19 *Paul Tillich:* The Protestant Era (*abridged*)

P 20 *Kenneth P. Oakley:* Man the Tool-maker

P 21 *W. E. Le Gros Clark:* History of the Primates

P 22 *Euclides da Cunha:* Rebellion in the Backlands

P 23 *John B. Watson:* Behaviorism

P 24 *B. A. Botkin:* Lay My Burden Down

P 26 *David Cecil:* Victorian Novelists

P 27 *Daniel J. Boorstin:* The Genius of American Politics

P 28 *David M. Potter:* People of Plenty

P 29 *Eleanor Shipley Duckett:* Alfred the Great

P 30 *Rudolf Carnap:* Meaning and Necessity

P 31 *Peter H. Buck:* Vikings of the Pacific

P 32 *Diamond Jenness:* The People of the Twilight

P 33 *Richmond Lattimore*, TRANSLATOR: The Odes of Pindar

P 34 *Marjorie Grene:* Introduction to Existentialism

P 35 *C. F. von Weizsäcker:* The History of Nature

P 36 *A. T. Olmstead:* History of the Persian Empire

P 37 *Charles Feidelson, Jr.:* Symbolism and American Literature

P 38 *R. W. B. Lewis:* The American Adam

P 39 *Smith Palmer Bovie*, TRANSLATOR: The Satires and Epistles of Horace

P 40 *Giorgio de Santillana:* The Crime of Galileo

P 41–43 *David Grene and Richmond Lattimore*, EDITORS: Greek Tragedies, Vols. 1–3

P 44 *Richard M. Weaver:* Ideas Have Consequences

45 *Weston La Barre:* The Human Animal
46 *Kate L. Turabian:* A Manual for Writers of Term Papers, Theses, and Dissertations
47 *Joseph Clancy,* TRANSLATOR: The Odes and Epodes of Horace
48 *Richmond Lattimore,* TRANSLATOR: Greek Lyrics
49 *Frieda Fromm-Reichmann:* Principles of Intensive Psychotherapy
50-51 *Harold C. Goddard:* The Meaning of Shakespeare, Vols. I and II
52 *Zellig S. Harris:* Structural Linguistics
53 *Robert Redfield:* The Little Community *and* Peasant Society and Culture
54 *Grover Smith:* T. S. Eliot's Poetry and Plays
55 *J. A. Pitt-Rivers:* The People of the Sierra
56 *Leonard B. Meyer:* Emotion and Meaning in Music
57 *Arthur W. Ryder,* TRANSLATOR: The Ten Princes
58 *Laura Fermi:* Atoms in the Family
59 *Pierce Butler:* An Introduction to Library Science
60 *E. H. Sturtevant:* Linguistic Change
61 *W. S. Tryon,* EDITOR: My Native Land
62 *Franz Alexander and Helen Ross,* EDITORS: The Impact of Freudian Psychiatry
63 *Richmond Lattimore,* TRANSLATOR: The Iliad of Homer
64 *Arnold van Gennep:* The Rites of Passage
66 *Alan Simpson:* Puritanism in Old and New England
67 *Yves R. Simon:* Philosophy of Democratic Government
68 *Rosemond Tuve:* Elizabethan and Metaphysical Imagery
69 *Gustave E. von Grunebaum:* Medieval Islam
70 *Oscar Jászi:* The Dissolution of the Habsburg Monarchy
71 *Nels Anderson:* The Hobo
72 *Elder Olson:* The Poetry of Dylan Thomas
73 *Howard H. Peckham:* Pontiac and the Indian Uprising
74 *Thom Gunn:* My Sad Captains and Other Poems
75 *Isabella Gardner:* The Looking Glass
76 *George Dillon,* TRANSLATOR: Three Plays of Racine
77 *Edward W. Rosenheim, Jr.:* What Happens in Literature
78 *Joshua C. Taylor:* Learning To Look
79 *Grosvenor Cooper:* Learning To Listen
80 *Carl Bridenbaugh:* The Colonial Craftsman
81 *Hans Reichenbach:* Experience and Prediction
82 *W. Lloyd Warner:* American Life (*revised*)
83 *Donald F. Bond:* A Reference Guide to English Studies
84 *Edward H. Levi:* An Introduction to Legal Reasoning
85 *W. R. Bascom and M. J. Herskovits,* EDITORS: Continuity and Change in African Cultures
86 *Robert Redfield and Alfonso Villa Rojas:* Chan Kom
87 *Robert Redfield:* A Village That Chose Progress
88 *Gordon R. Willey and Philip Phillips:* Method and Theory in American Archaeology
89 *Reuel Denney:* In Praise of Adam
90 *Eric Wolf:* Sons of the Shaking Earth

PHOENIX BOOKS

P 91 *Paul Goodman:* The Structure of Literature

P 92 *Joachim Wach:* Sociology of Religion

P 93 *Wallace Fowlie:* Mallarmé

P 94 *Myron Lieberman:* The Future of Public Education

P 95 *Archibald Gillies Baker:* A Short History of Christianity

P 96 *Harold J. Leavitt:* Managerial Psychology

P 97 *Gertrude Himmelfarb:* Lord Acton

P 98 *Mary K. Eakin:* Good Books for Children

P 99 *Herman Melville:* Billy Budd, Sailor, *edited by Harrison Hayford and Merton M. Sealts, Jr.*

P 100–101 *Earl J. Hamilton, Harry G. Johnson, and Albert Rees,* EDITORS: Landmarks in Politic Economy, Vols. I and II

P 102 *Hans J. Morgenthau:* Politics in the 20th Century, Vol. I: The Decline of Democratic Politi

P 103 *Hans J. Morgenthau:* Politics in the 20th Century, Vol. II: The Impasse of American Foreig Policy

P 104 *Hans J. Morgenthau:* Politics in the 20th Century, Vol. III: The Restoration of America Politics

P 105 *Sol Tax,* EDITOR: Anthropology Today—Selections

PHOENIX SCIENCE SERIES

PSS 501 *Carey Croneis and William C. Krumbein:* Down to Earth

PSS 502 *Mayme I. Logsdon:* A Mathematician Explains

PSS 503 *Heinrich Klüver:* Behavior Mechanisms in Monkeys

PSS 504 *Gilbert A. Bliss:* Lectures on the Calculus of Variations

PSS 505 *Reginald J. Stephenson:* Exploring in Physics

PSS 506 *Harvey B. Lemon:* From Galileo to the Nuclear Age

PSS 507 *A. Adrian Albert:* Fundamental Concepts of Higher Algebra

PSS 508 *A. A. Michelson:* Light Waves and Their Uses

PSS 509 *Walter Bartky:* Highlights of Astronomy

PSS 510 *Frances W. Zweifel:* A Handbook of Biological Illustration

PSS 511 *Henry E. Sigerist:* Civilization and Disease

PSS 512 *Enrico Fermi:* Notes on Quantum Mechanics

PSS 513 *S. Chandrasekhar:* Plasma Physics

PSS 514 *A. A. Michelson:* Studies in Optics

PSS 515 *Gösta Ehrensvärd:* Life: Origin and Development

PSS 516 *Harold Oldroyd:* Insects and Their World